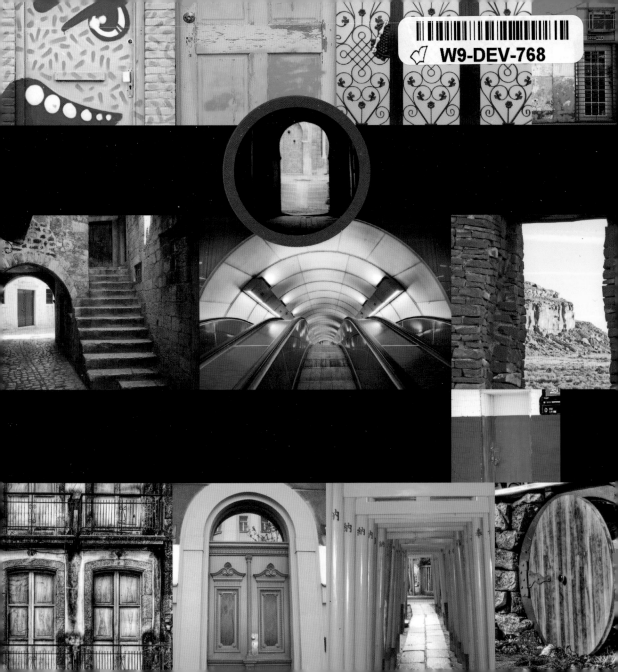

W9-DEV-768

F PASSAGES OCUS:

FOCUS:
PASSAGES
Your World, Your Images

LARK

A Division of Sterling Publishing Co., Inc.
New York / London

Senior Editor:
Nicole McConville

Image Editor:
Cassie Moore

Editor:
Julie Hale

Art Director:
Travis Medford

Cover Designer:
Celia Naranjo

Library of Congress Cataloging-in-Publication Data

Focus, passages : your world, your images. -- 1st ed.
 p. cm.
 Includes index.
 ISBN 978-1-60059-680-3 (hc-plc : alk. paper)
 1. Street photography. 2. Architectural photography. 3. Photography, Artistic. I. Lark Books.
 TR659.8.F63 2010
 779--dc22

 2010000574

10 9 8 7 6 5 4 3 2 1

First Edition

Published by Lark Books, A Division of Sterling Publishing Co., Inc.
387 Park Avenue South, New York, NY 10016

Text © 2010, Lark Books, a Division of Sterling Publishing Co., Inc.
Photography © 2010, Artist/Photographer

Distributed in Canada by Sterling Publishing,
c/o Canadian Manda Group, 165 Dufferin Street
Toronto, Ontario, Canada M6K 3H6

Distributed in the United Kingdom by GMC Distribution Services,
Castle Place, 166 High Street, Lewes, East Sussex, England BN7 1XU
Distributed in Australia by Capricorn Link (Australia) Pty Ltd.,
P.O. Box 704, Windsor, NSW 2756 Australia

If you have questions or comments about this book, please contact:
Lark Books
67 Broadway
Asheville, NC 28801
828-253-0467

Manufactured in China

ISBN 13: 978-1-60059-680-3

For information about custom editions, special sales, premium and corporate purchases, please contact Sterling Special Sales Department at 800-805-5489 or specialsales@sterlingpub.com

For information about desk and examination copies available to college and university professors, requests must be submitted to academic@larkbooks.com. Our complete policy can be found at www.larkbooks.com.

Contents

fo • cus: a central point of attraction

Your World
When walking down a busy city street or strolling through a wooded park, do you scan your surroundings with hungry eyes? Do you find yourself on a visual safari hunting snapshots of beauty, intrigue, or surprise amid the ordinary fodder of the everyday? All of us, from professionals to beginners, can take engaging and even breathtaking photographs just by observing the world around us. Meaningful images are everywhere, just waiting to be spotted and captured.

Your Images
Visit any number of online image-hosting sites, and you'll quickly realize how eager we are to snap, organize, and share what we see—in the form of millions upon millions of digital images. Technology has not only provided the tools, it has also fostered a vibrant community ready to embrace and encourage our infatuation with the visual image.

The Series
In *Focus: Passages*, the second entry in a new series, this community's passion for the evocative power of doors, tunnels, and other passageways takes center stage. From a graffiti-scrawled urban door and an aged barn door to the elegance of a glass door glowing with dappled light and a curious circular door set into an ivy-covered rock wall, these images instantly transport. Numerous creative interpretations of passages also appear, including the entrance to an old mine shaft, shadowy alleyways, a modern escalator tunnel—even a dollhouse door whimsically placed on a facade to catch the eye of attentive passersby.

The Focus
Doors are the means through which we move about our world, the threshold between one place and another. An open door can be an invitation, a temptation, or a mystery waiting to be explored. Closed, a door can convey separation, a challenge, or the understanding that all one needs to do is reach out and open it. Most of us would agree that doors inspire the desire to find out what's on the other side.

Within these pages you'll find the work of 124 photographers from 30 different countries, along with their reflections on their images, details on where the photos were taken, and thoughts on the theme of passages in general. Their images and words range from the sublime to the provocative—just like the passages we encounter every day.

Peruse, and discover the magic before your eyes.

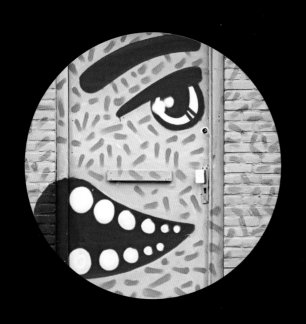

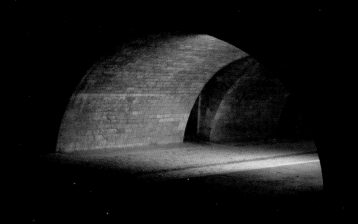

Genséric Morel
The Mouse Hole
Paris, France
I took this picture while walking alone by the banks of the Seine River in Paris. It was dusk—a rather scary time—when I came to this bridge with its illuminated arch. It offered just what I needed at that moment: light! But it seemed too beautiful to be real. I felt like a mouse seeking cheese about to jump in a trap. I'll never know if the door was a trap, though, because I avoided it and used the stairs to get on the bridge.

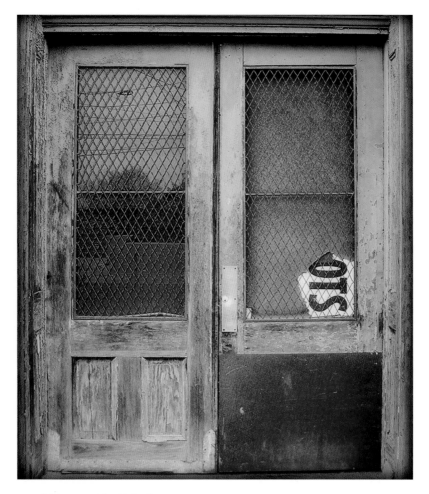

Kendrick Wayne Shackleford
OTS Multi-Tone
Montgomery, Alabama

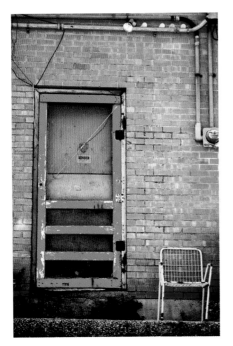

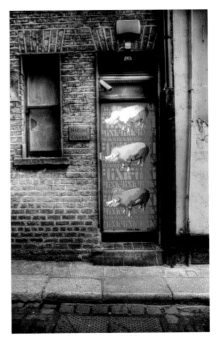

Christian Anderson
Back Door of Shop in Old Strip Center
Farmer's Branch, Texas
One of my all-time favorites. I was riding through the
back alley that ran behind this old strip center when
I saw this beautiful old turquoise door. You can learn
a lot more about a building by looking at the back of
it instead of its front side.

Brian Sparks
Three Little Pigs
Dublin, Ireland

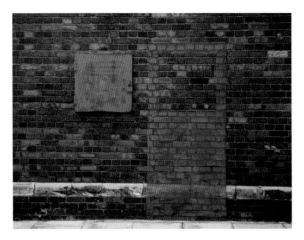

Kangan Arora
Walking Through Walls
London, England

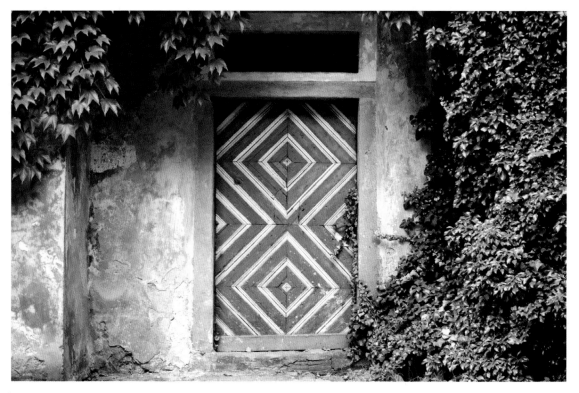

Alexandre De Abreu
Anno 1606
Steyr, Austria

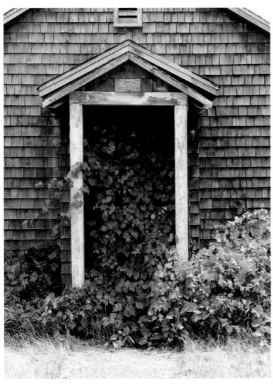

Patrick Cummins
Barracks, CFB Picton - July 7, 2007
Picton, Ontario, Canada

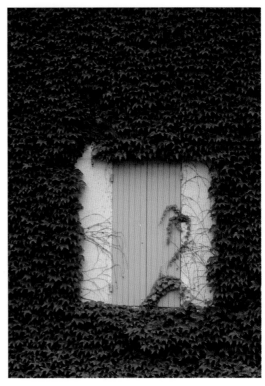

Adam Ormerod
Doorway #1
L'Isle-sur-la-Sorgue, Provence, France

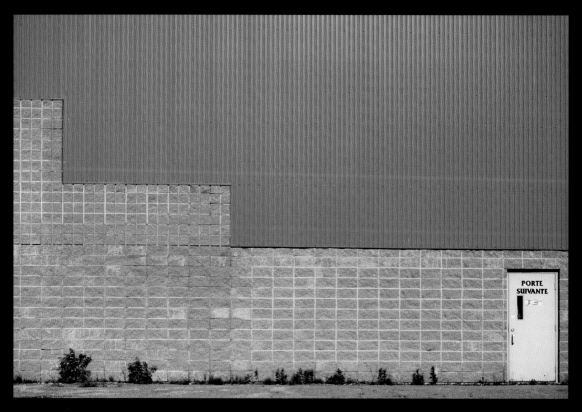

Delphine Prieur
Next Door
Trois-Rivières, Quebec, Canada
Porte suivante (as written on the door) means "next door" in French. As I am always looking for doors to photograph, I thought this one was quite ironic!

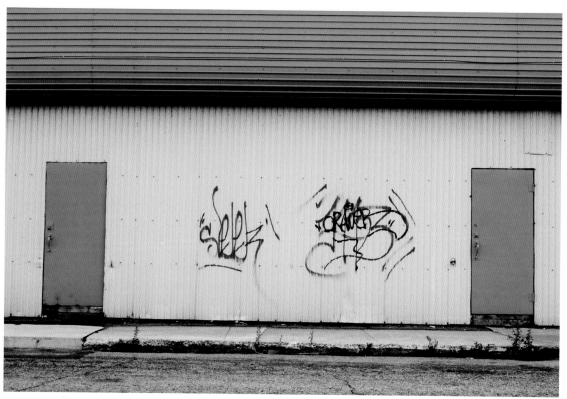

Delphine Prieur
Scribble Seeking
Cap-de-la-Madeleine, Quebec, Canada

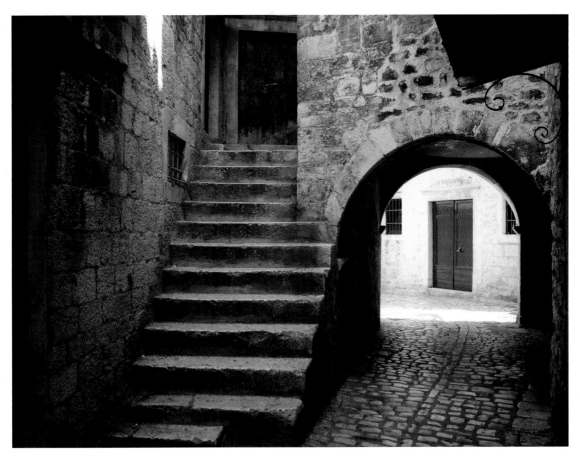

Amaury D. Henderick
Trogir
Trogir, Croatia

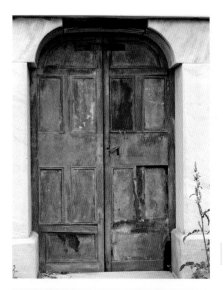

Timothy J. Grunsby
In Through the Out Door
Philadelphia, Pennsylvania

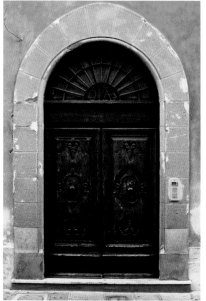

Maximiliano Heiderscheid
Untitled
Pisa, La Toscana, Italy
I was in Italy for work and I found this door a few meters from the tower of Pisa. I liked the solid wood door, the smithy work on top and the orange color on the wall.

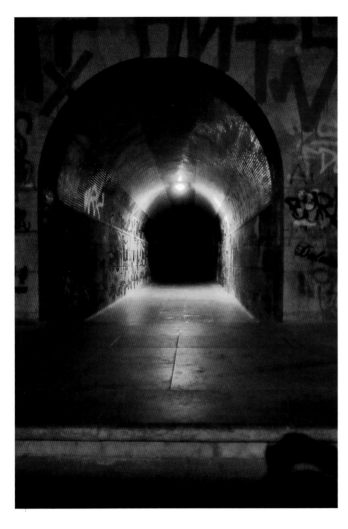

Frederic Giet
Into the Tunnel
Estoril, Portugal

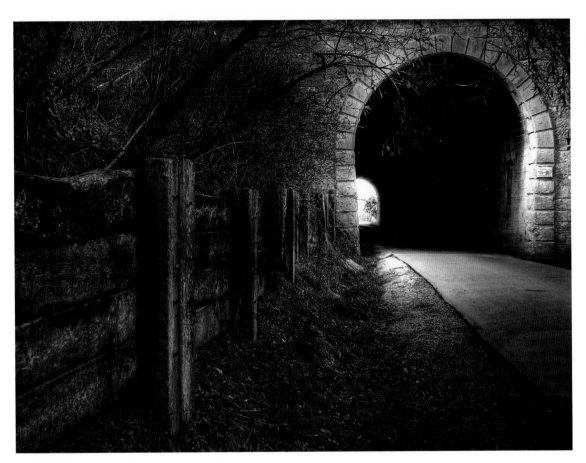

Lui G. Marin
VV01
Olvera, Spain

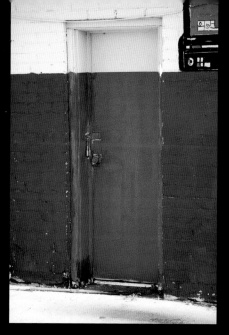

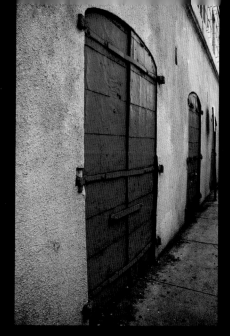

Christian Anderson
Bright Blue Door off Maple Avenue
Dallas, Texas

Rick Lane
Blue Door
St. Thomas, U.S. Virgin Islands

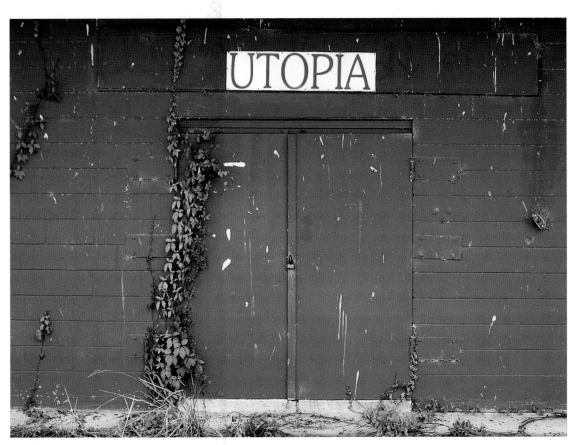

Kendrick Wayne Shackleford
Utopia
Pinelevel, Alabama

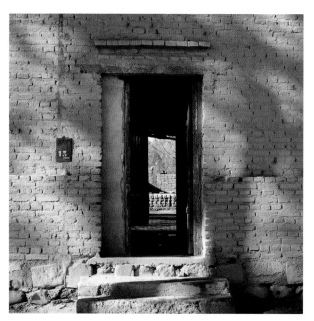

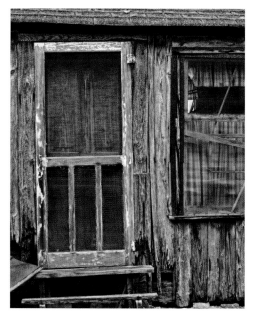

Maximiliano Heiderscheid
Interior
Guandacol, La Rioja, Argentina
In the summer, the people of Guandacol leave the doors of
their houses open to let in the fresh afternoon air.

Debra Nickol/Warped Mind Photography
Back Door
Waxhaw, North Carolina

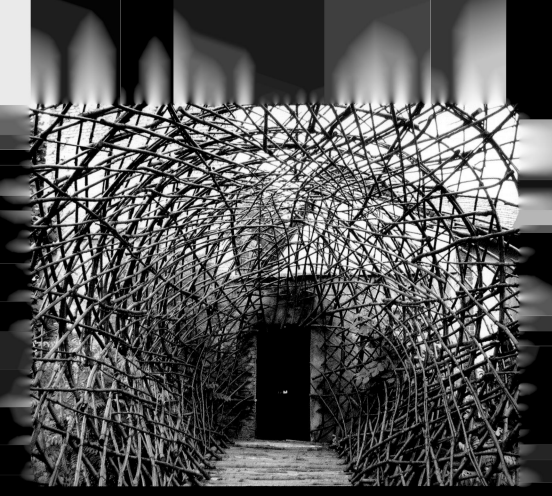

Vittorio Gurgone

Passerella di Gelsomini sul fiume Perduto (Jasminum Flying Bridge over the Lost River)

Gallarate, Italy

This flying bridge was created by Italian artist Giuliano Mauri. It celebrates the architecture that

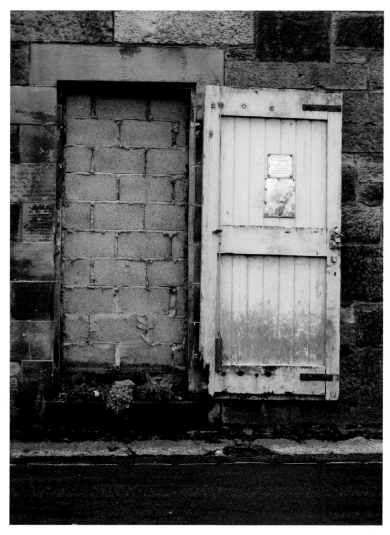

Grace Liu
Open Closed Door
Edinburgh, Scotland

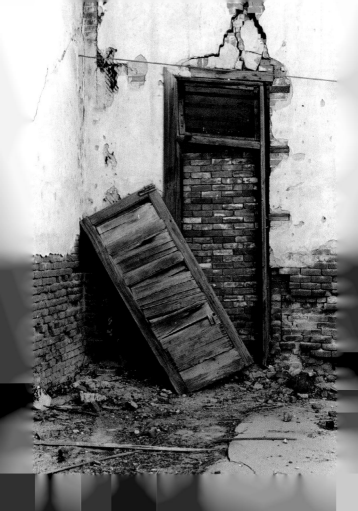

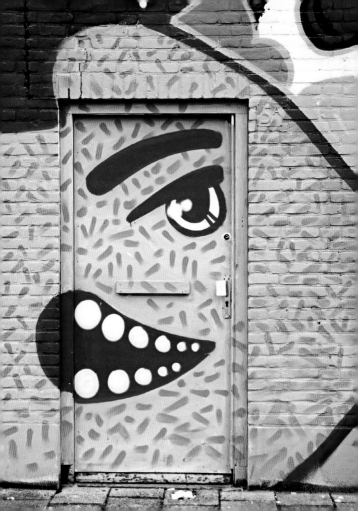

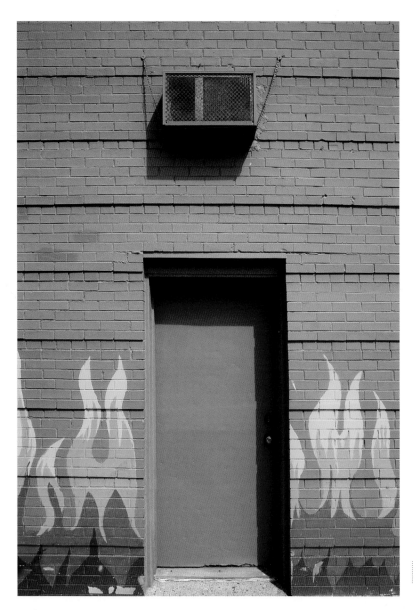

Donald A. Jones
Entrance to the Hot Purple World
Royal Oak, Michigan

Klaus von Frieling
Favourite Wall
Ravensburg, Germany

Delphine Prieur
Green Glimmer
Montreal, Quebec, Canada

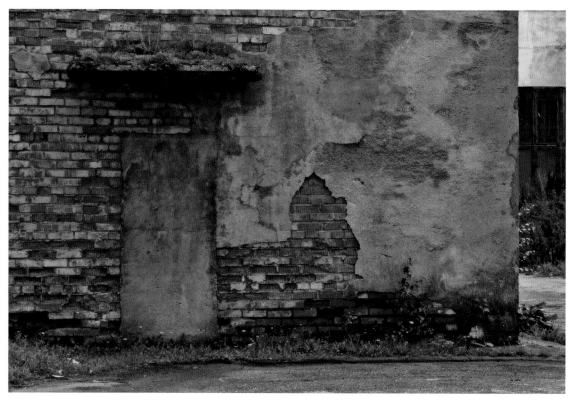

Liis Roden
The Ghost
Tallinn, Estonia

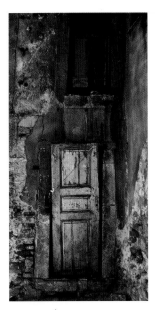

Ertuğrul İncel
Asiboyali evin Kapisi
(The Door of the Brick-Red House)
Zonguldak, Turkey

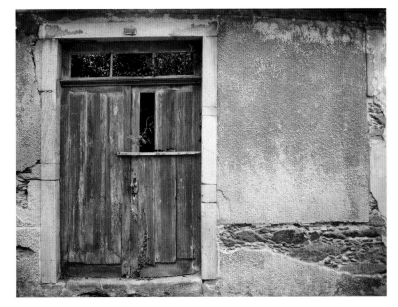

Nicole McConville
In Decay
Espinho, Portugal

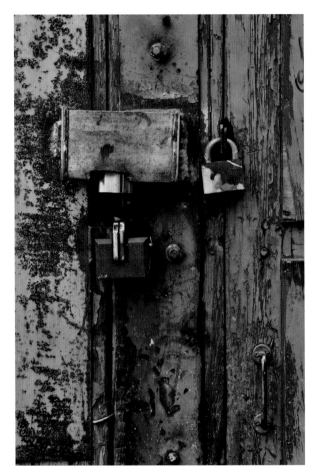

Liis Roden
Stern Guards
Tallinn, Estonia

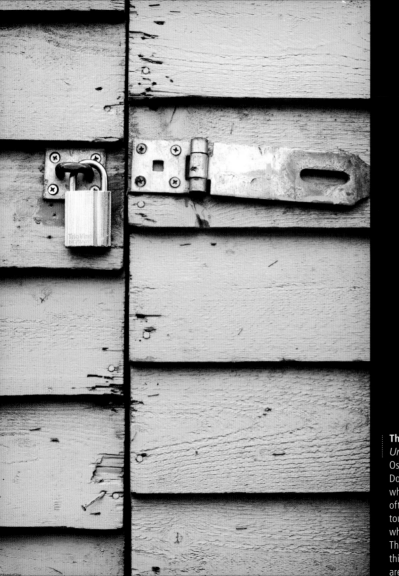

Thomas Haverkamp
Unlocked
Oslo, Norway
Doors are doors in most cases. However
when you wander through cities you
often encounter doors that are special,
touched by their creators, by the people
who live or work behind these doors.
They can tell something about what you
think is locked behind it, although you
are never sure. A door is a chance.

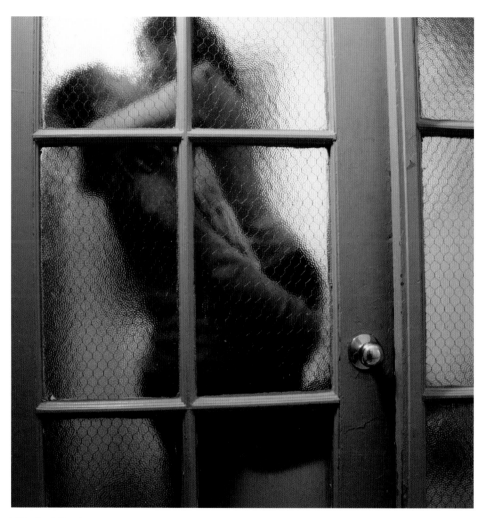

Elizabeth Sarah
promises and resolutions
New York, New York

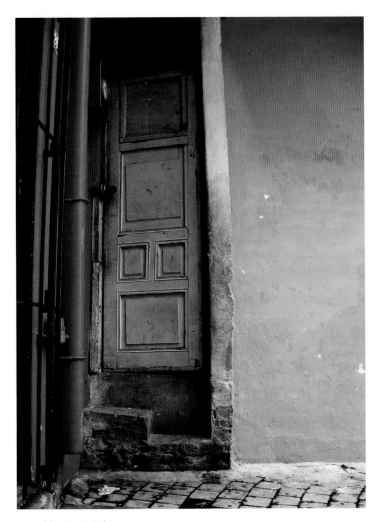

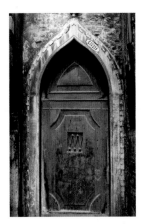

Michele Tizzoni
The Door
Venice, Italy

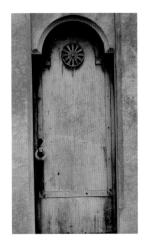

Arnoldo García Rule
Let My Love Open the Door
Villahermosa, Tabasco, Mexico

Timothy J. Grunsby
Blue Monday
Philadelphia, Pennsylvania

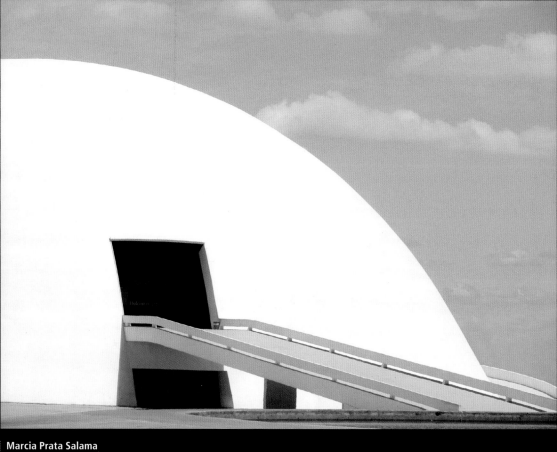

Marcia Prata Salama
Entrance to the National Museum, designed by architect Oscar Niemeyer
Brasília, Brazil

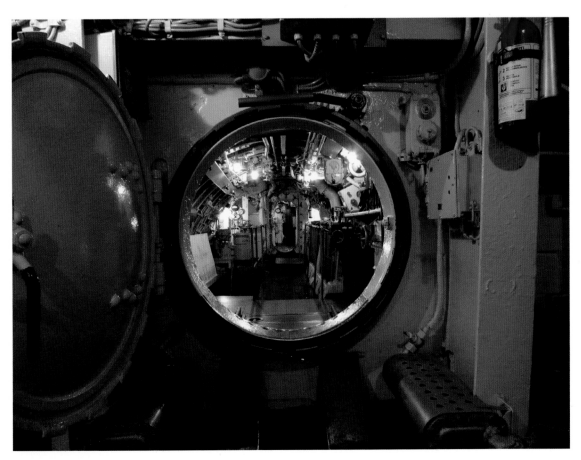

Manuel Cazzaniga
Submarine Door, Maritime Museum
Tallinn, Estonia

Delphine Prieur
Forgotten Art
Cap-de-la-Madeleine, Quebec, Canada

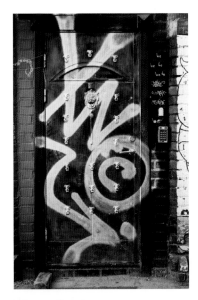

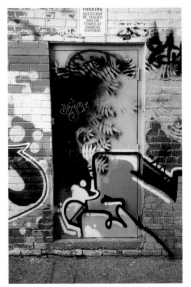

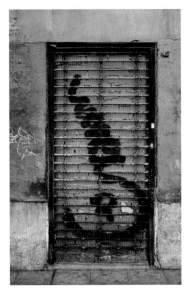

Thomas Haverkamp
Another Door
Oslo, Norway
A door is a chance.

Patrick Cummins
Graffiti Door #25–7, October 3, 2004
Toronto, Ontario, Canada

Petter Palander
In the Meantime
Madrid, Spain

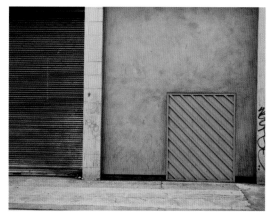

Kangan Arora
Urban Flattened
London, England

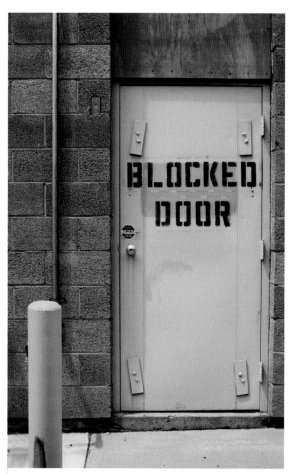

Henry Noeding
Blocked Door
Albuquerque, New Mexico

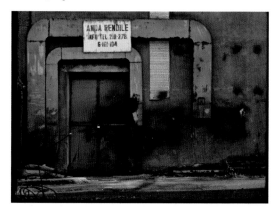

Liis Roden
Call Me, I Feel So Blue
Tallinn, Estonia
Doors are objects that divide the world into smaller sub-worlds. They can mean safety, restriction, or opportunity, and with ease they shift us from one of those conditions to another.

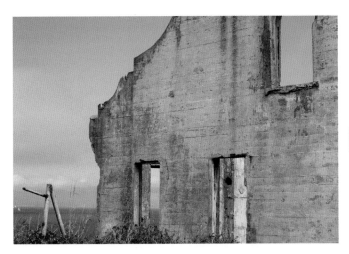

Alison Voss
View from Alcatraz
Alcatraz Island, San Francisco, California
I immediately whipped out my camera when I saw
this building. As I was shooting the passages, I
thought about the building's history and the people
who once occupied it. I wondered what they thought
about when they looked at the San Francisco Bay
from its windows.

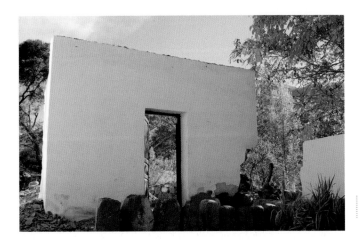

Maximiliano Heiderscheid
Untitled
San Antonio, Salta, Argentina

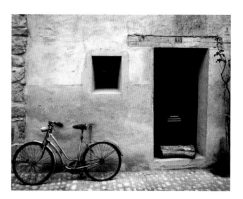

Esteban Chiner Sanz
Old Bike
Valderrobres, Spain

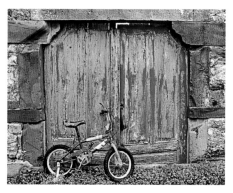

Flioukas Apostolis
Bike on Red Door
Spiladia Chios, Greece

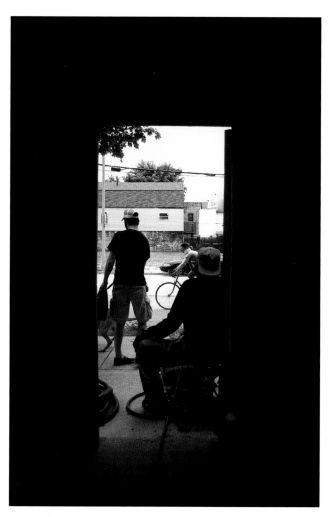

Luke J. Rosynek
Milwaukee Bicycle Collective
Milwaukee, Wisconsin

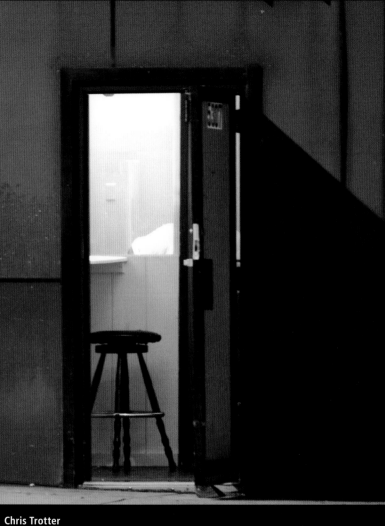

Chris Trotter
Whatever You Do . . .
Baltimore, Maryland

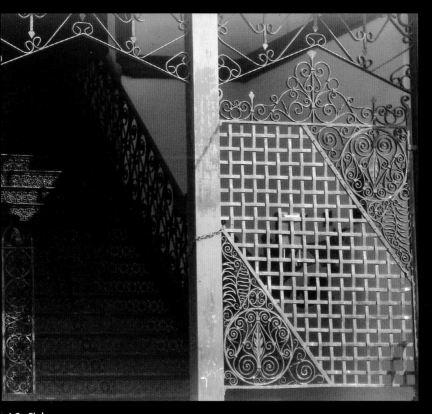

J.C. Fink
Key West Door
Key West, Florida
To me, a door symbolizes the liminal space between one place and another. A door equals transition, metamorphosis, movement, progress, opportunity, and the unknown. Yet it also equals a sense of comfort and a sense of home.

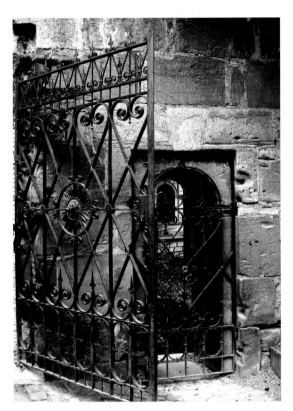

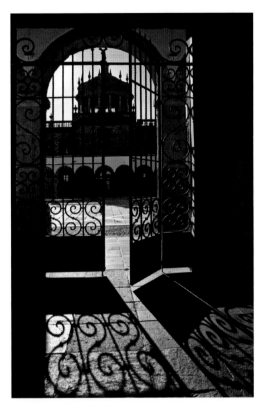

J.C. Fink
Heidelberg Castle Door
Heidelberg, Germany

Leonardo Ramon Diaz
Cabañas Cultural Institute
Guadalajara, Mexico
I wanted to photograph this building, so I watched it carefully to find the image I was looking for. When I noticed how beautiful the door was and the incredible way in which the light was making shadows across it, I knew I'd found the moment I wanted to capture with my camera.

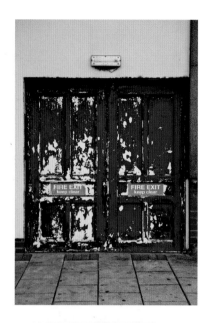

Christian Cable
Better Days
Blackpool, England
The world is full of doors, both actual and imagined. A closed door is a mystery that urges us to solve it, while an open door is an invitation to a friendlier place. Is something hidden behind a closed door? Is that door a test? What if we opened it and walked into a secret world?

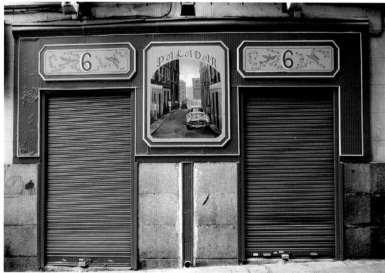

Petter Palander
Blue Bar
Madrid, Spain

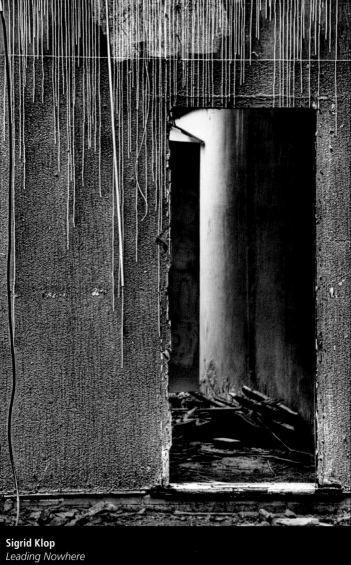

Sigrid Klop
Leading Nowhere
Dordrecht, Netherlands

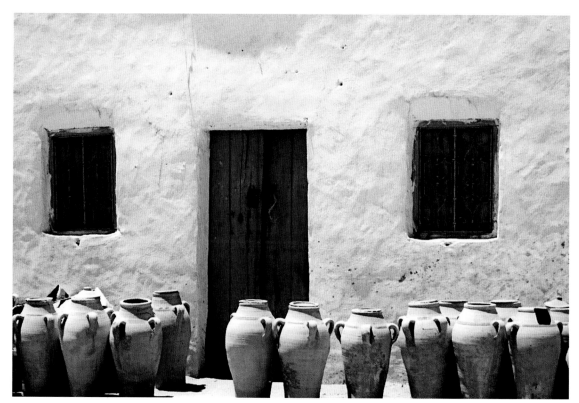

Sigrid Klop
Jars
Djerba, Tunisia

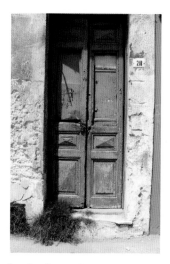

Judy Allen-Rodgers
Blue Door at #218
Buenos Aires, Argentina

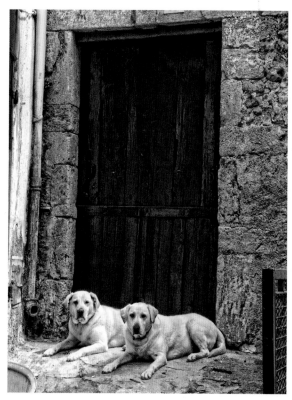

Bryan W. Bellars
Village Door, Mediterranean Blue
Thezan-les-Beziers, Languedoc, France
This building is part of the old village butchery, which dates back
to the 1500s. I love the way the ancient door with its coat of
Mediterranean blue pops out from the rough stone walls.

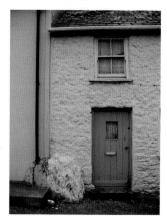

Jeanne M. Julian
Blue Door, Kenmare
Kenmare, County Kerry, Ireland

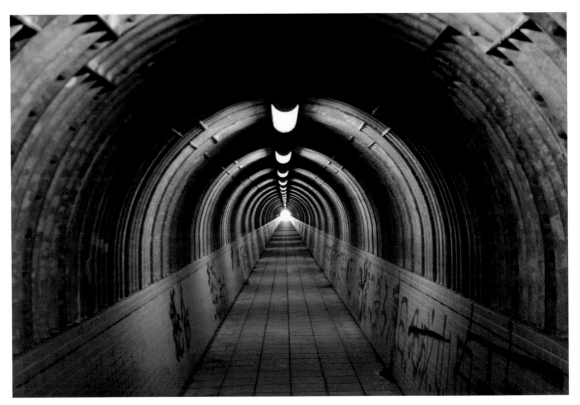

Toshihiro Oimatsu
Life
Yokohama, Japan

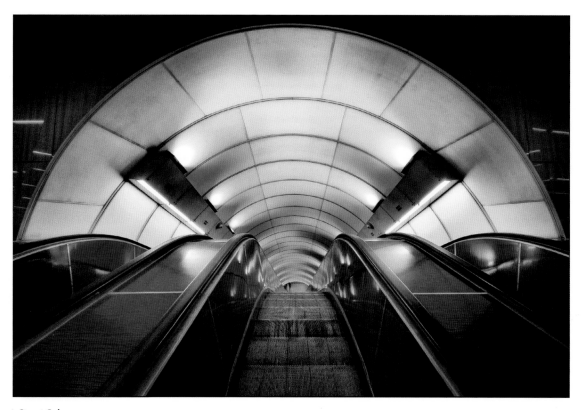

Steve Coleman
Jinonice Metro Station
Prague, Czech Republic
I've always loved the Prague metro system and feel it provides wonderful subject matter for photography. Every station is different, with its own unique ambience and aesthetic. Some stations are quaint and old-fashioned, while others are stunningly futuristic. I'd taken lots of shots looking up the escalators in the metro stations, but this image was the first I'd taken from the top. I'm fascinated by the contrasting and converging lines in this image.

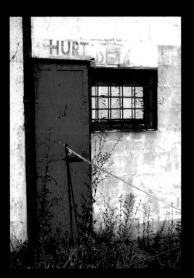

Christian Anderson
"Hurt" Means "Wholesale" in Polish
Gdansk, Poland

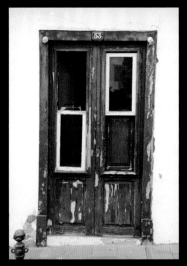

Marcel Moré
Door in Decay
La Palma, Spain

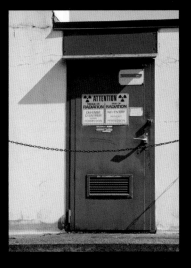

Rainer Hungershausen
Radiation
Geneva, Switzerland

Luke J. Rosynek
Front Door, Birdhouse
Independence, Wisconsin

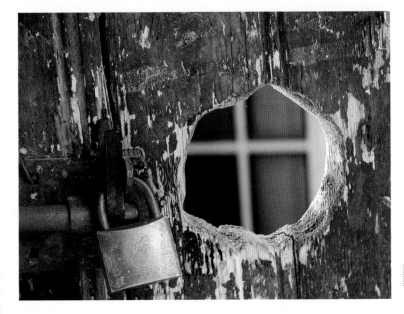

Gianfranco Liccardo
Curiosity
Bussana Vecchia, Imperia, Italy

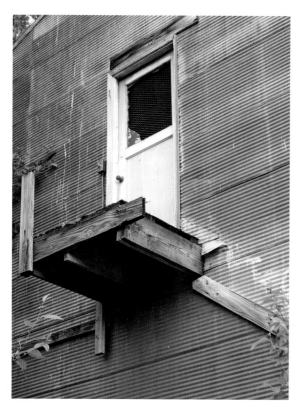

Christian Anderson
Door at Abandoned Gas Station
Dallas, Texas

Neil R. Gilham
Happy Landing
Lynnwood, Washington
This door is on the side of a Quonset building that's hidden behind a fast-food restaurant and a tire store. I like how the stairs have disappeared, yet the image of them remains on the side of the building. I seek out places like this in order to record what's there before it's gone.

Christian Anderson
Rusting Door on Old Sheet-Metal Building, Industrial Area
Dallas, Texas

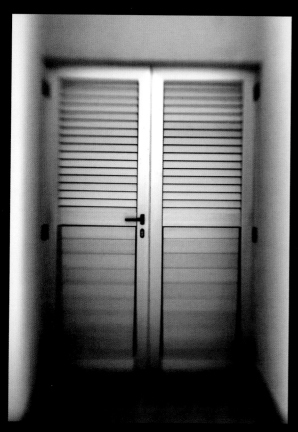

Simon Rooke
The Other Side
Paphos, Cyprus
This image reminds me of a dream—a dream in which I can't find
my way, everything is fuzzy, and then a door appears suddenly right
in front of me.

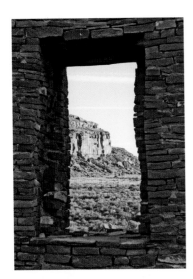

Neil R. Gilham
Pueblo del Arroyo
Chaco Culture National Historic Park, New Mexico

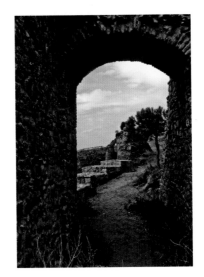

Lui G. Marin
Door Time
Ronda, Spain

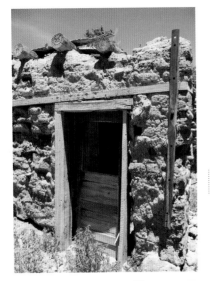

Jeanne M. Julian
Door, Abiquiu
Abiquiu, New Mexico

Doors are paradoxes: They invite you in by hinting at the mysteries they conceal, yet they also shut you out. They beckon, and they barricade. Their styles convey what's valued in their cultural contexts: simple or ornate architecture, functional or formal design. A battered door can be the saddest thing about a falling-down house because it conveys—even more than a caved-in roof or broken set of stairs—a sense of giving up.

se
ns
ken at
ings at
most
h the

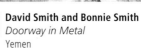

David Smith and Bonnie Smith
Doorway in Metal
Yemen

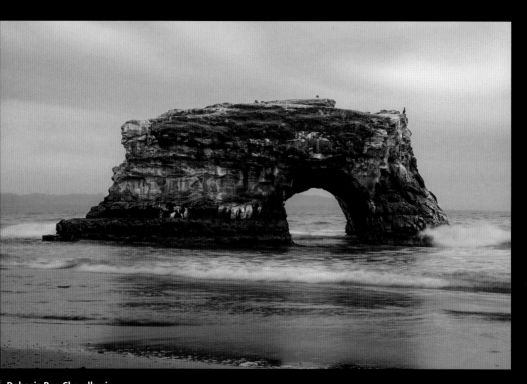

Debasis Roy Choudhuri
Natural Bridge
Santa Cruz, California

Pirlouiiiit

Keyhole to the Medina

Tunis, Tunisia

A door is like the wrapping paper on a present. You never know what you'll find—a room, a tunnel, a staircase—until you open it.

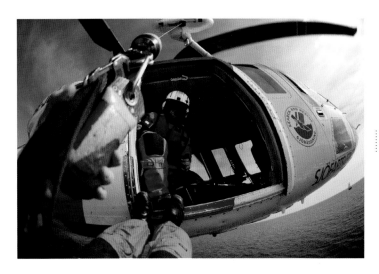

Rickard Gillberg
Helicopter Door
Altitude: 50 feet (15 m),
Gulf of Bothnia, near Hudiksvall, Sweden
This image was taken from a rescue swimmer's perspective while leaving the door of the helicopter. It's a picture I'd been wanting to take for quite some time. It took guts to hold the camera with one hand while hanging out of a helicopter, but the experience was worth it.

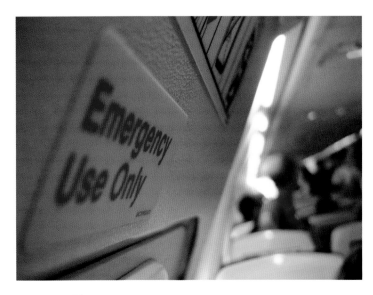

Abel Pau Garcia
Emergency Use Only

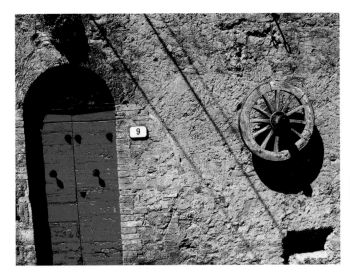

J.C. Fink
Door and Wagon Wheel
Siena, Italy
During a horseback ride outside of Siena, Italy, I passed a house with a bright red door and a wagon wheel. I managed to convince my horse to stop (for the most part), then I snapped this picture.

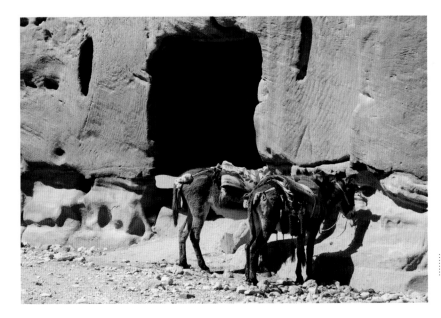

Gunter Hartnagel
Donkeys at a Manmade Cave
Near the Treasury
Petra, Jordan

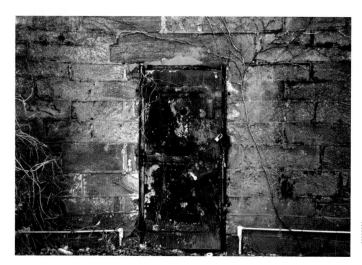

John Sturgis
Rusty Metal Door, Eastern State Penitentiary
Philadelphia, Pennsylvania

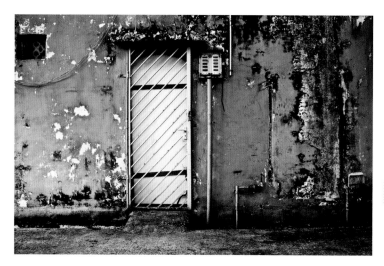

Jeremy Lim
White Door
Bussorah Street, Singapore
Doors represent possibilities. They're start-
ing points and places to return to. They're
the protectors of secrets.

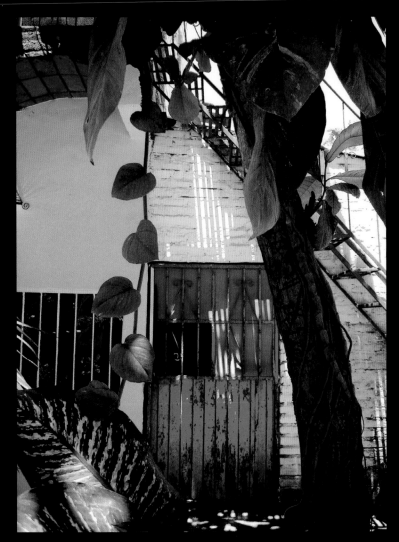

J.C. Fink
Nayarit Door
Nayarit, Mexico

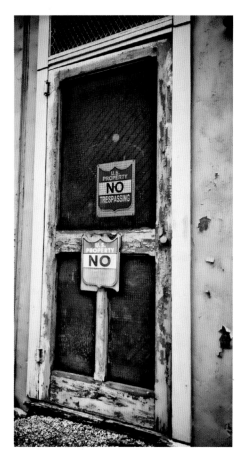

Debra Nickol/Warped Mind Photography
Green Door
Thurman, West Virginia

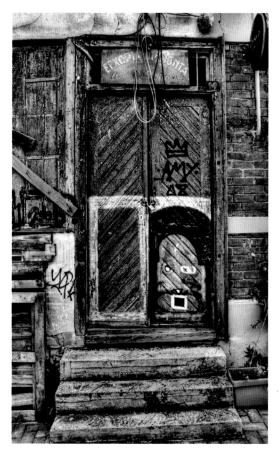

Dimitris Amvrazis
A Door and a Face
Larissa, Greece

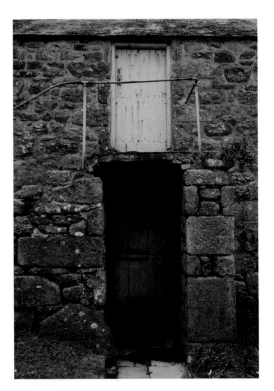

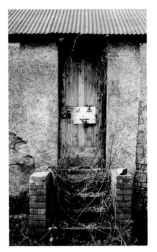

Dimitris Amvrazis
Old Door
Larissa, Greece
What I love about doors is that they symbolize boundaries, limits. A door is a sign that separates personal space from public space.

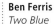

Ben Ferris
Two Blue
Marvah, Cornwall, England
For me, a door in itself isn't intriguing. What fascinates me are the stories a door can create in my mind. What's behind it? Where does it lead? Until I open that door, all that I know or presume to know is generated by my own imagination. The passage can lead wherever I want it to. I like to photograph doors straight on in order to create simple compositions. I want viewers to feel as though they were facing the door, ready to reach for the handle, ready to discover what waits behind it.

Ben Ferris
Old Oak
Slaughterford, Wiltshire, England

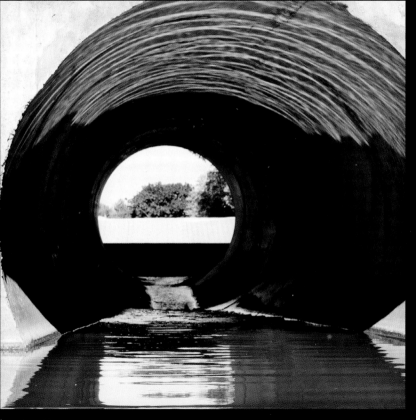
Kevin White

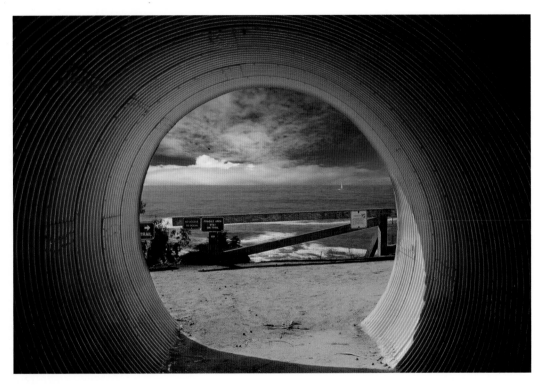

Debasis Roy Choudhuri
Tunnel Vision, Julia Pfeiffer Burns State Park
Big Sur, California

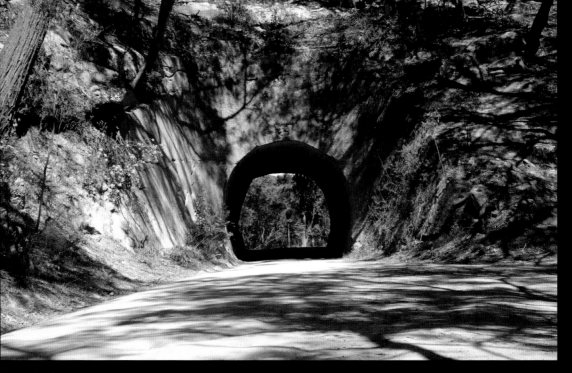

Bert Maathuis
Dirtroad Tunnel 2
Wombeyan Caves,
New South Wales, Australia

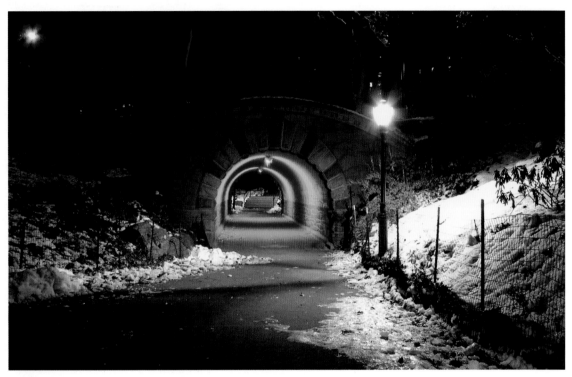

Diego Silvestre
Warm Path on the Park I
Central Park, New York City
I took this picture on a winter night in New York City. I was searching for a place to shoot, and then I saw this passage. Its wonderful warm light contrasted with the cold air and frozen ground. I felt I had to photograph it.

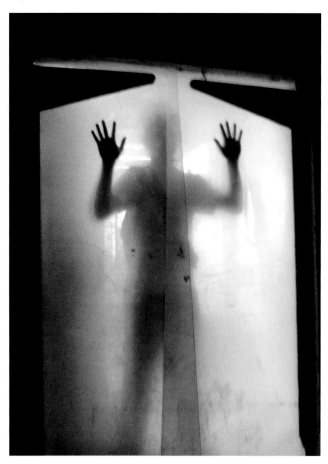

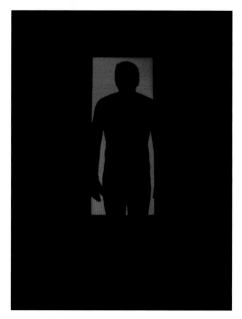

João Cruz
Man at Red Door
Porto, Portugal

Rob Rickels
Abandoned Hospital Doors
RAF Nocton Hall, Lincolnshire, England

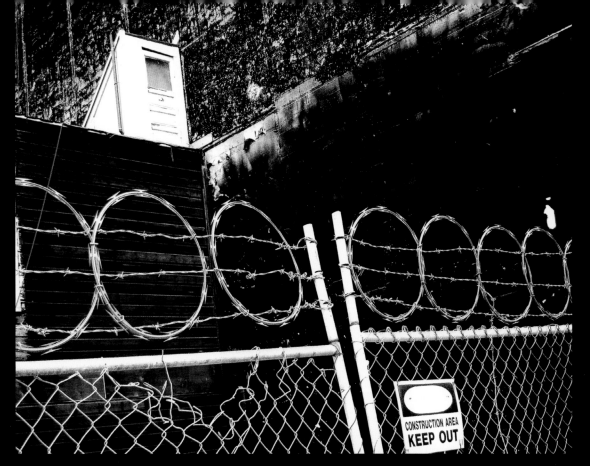

J.C. Fink
Door to Nowhere
San Francisco, California

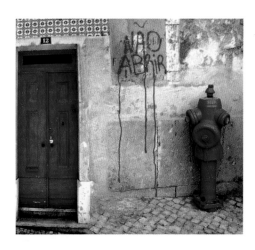

Tamara Lebrecht
Não Abrir
Lisbon, Portugal
This door fascinated me not only because of its bright color but because of the words written next to it: "Don't Open." What might be behind the door that the owner doesn't want us to see?

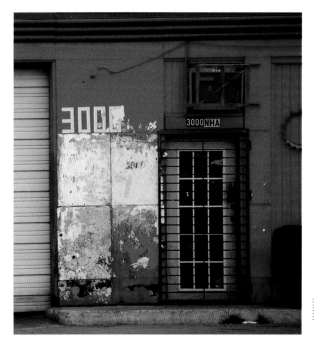

Christian Anderson
Bright Red Building off Hampton
Dallas, Texas

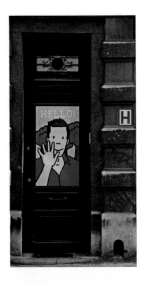

Brian Sparks
Hello Stranger!
Brussels, Belgium
Brussels is a city of contradictions and quirkiness, where you find the old and the new jostling for attention. Unexpected things lie around every corner—like this door.

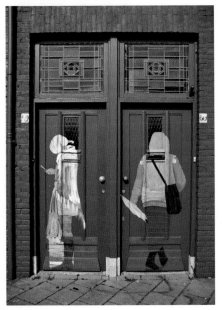

Modra Malderis
Doors Apart
Montreal, Quebec, Canada
I'm intrigued by these two doors because they're so close together, like twins, and yet so different.

Frans van Rijnswou
Delft Blue Is Not Just for Pottery
Delft, Netherlands

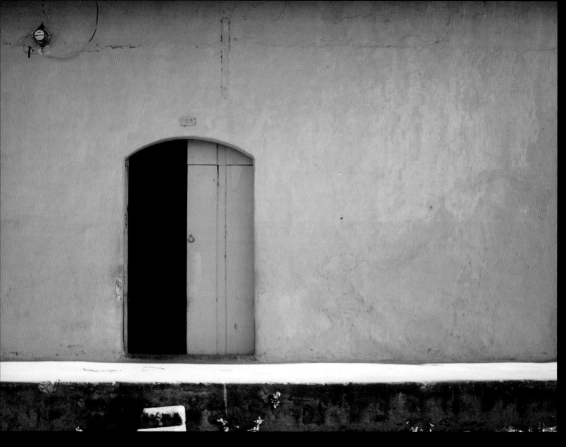

Tamara Lebrecht
Turquoise Door
Granada, Nicaragua
As I was walking through the streets of Granada, Nicaragua, I was surprised
by the city's colorful doors. Each door adjoins the next one, and each is
unique! This bright turquoise one eclipses all its neighbors.

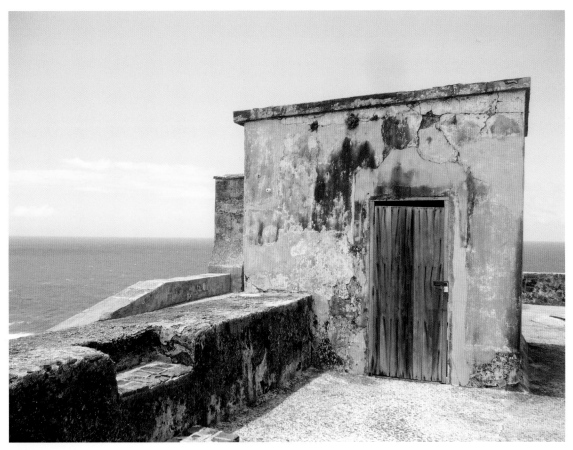

Pace Ebbesen
Door at El Morro
San Juan, Puerto Rico
Doors hold the promise of a new experience.

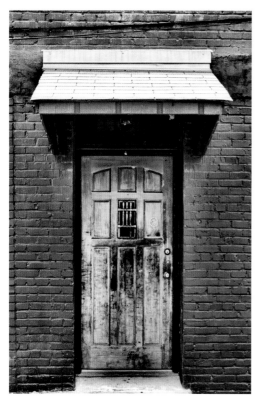

Kendrick Wayne Shackleford
Back Door on Blue
Wetumpka, Alabama

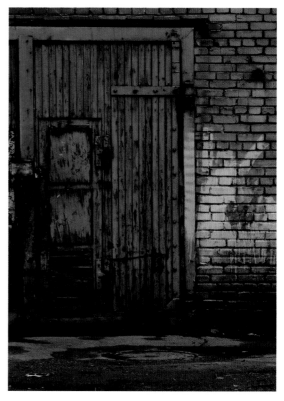

Liis Roden
Locked Up Blues
Tallinn, Estonia

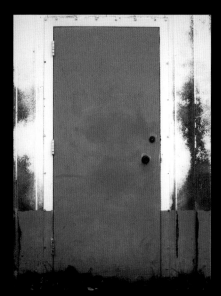

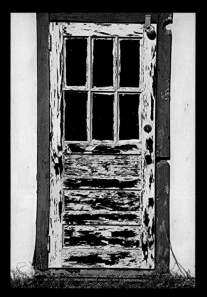

Darrin Hagen
Blue
Edmonton, Alberta, Canada
I like wandering through the industrial areas of
my city, looking for moments of beauty in the
midst of otherwise ugly surroundings. Sometimes
all it takes is a splash of color.

Kendrick Wayne Shackleford
Weathered
Marietta, Georgia

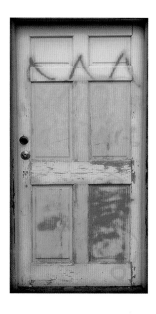

Kendrick Wayne Shackleford
Door with Teeth
Cartersville, Georgia

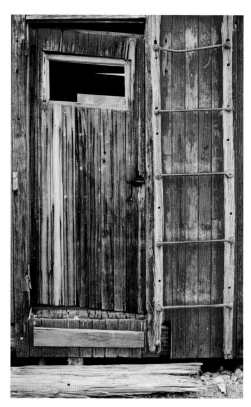

Tony Triolo
Caboose #4
Rhyolite Ghost Town, Rhyolite, Nevada

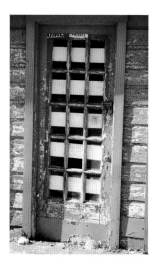

Christian Anderson
*Door to Rose's Hamburgers on
Greenville Avenue*
Dallas, Texas

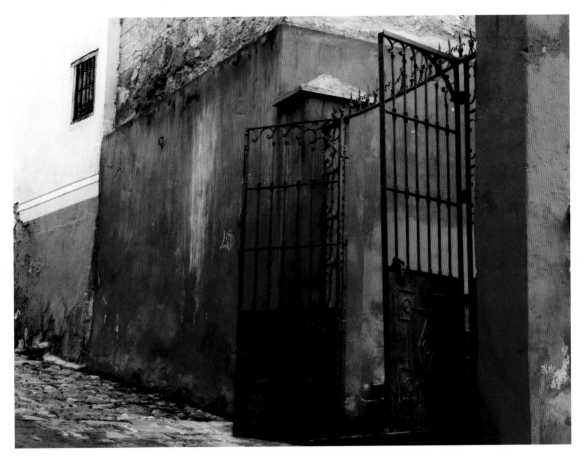

Leonardo Ramon Diaz
Door on Red
Guanajuato, Mexico
Every door takes us to a different world. Every door is a silent witness of history.
When I see a special door and capture its image, it makes me think of the people
who have crossed its threshold.

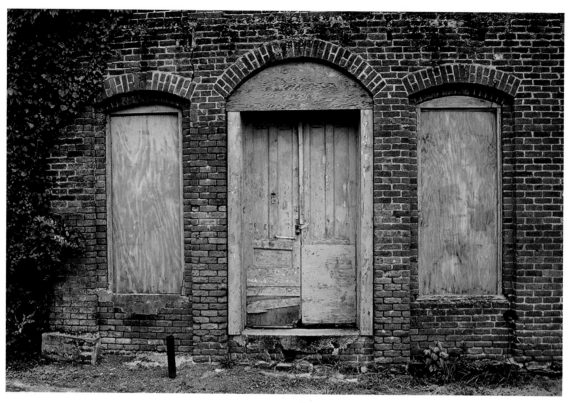

Kendrick Wayne Shackleford
Blue on Brick
Dallas, Georgia

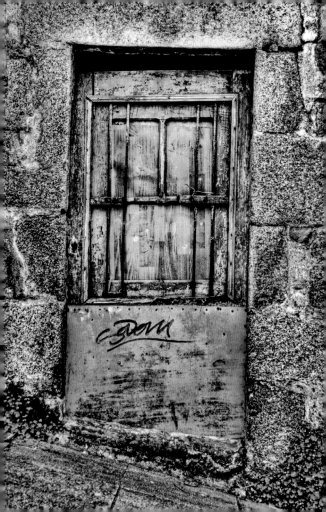

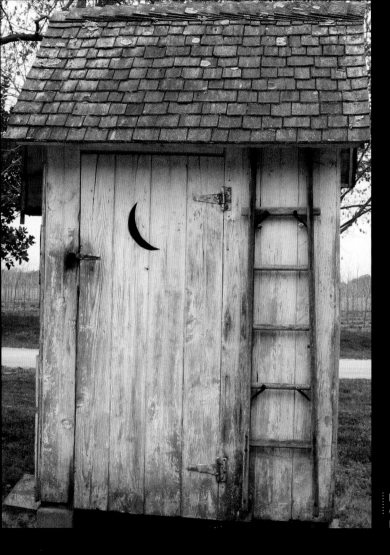

Robin Stopak
Out by the Outhouse
Delaware

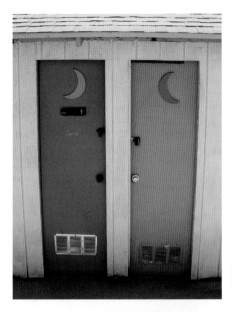

Matthew E. Cohen
Pink & Blue
Lemoore, California

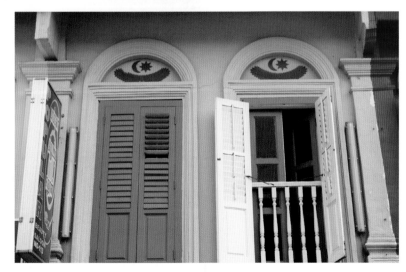

Chua Wei Luck
Shop House at Little India
Singapore

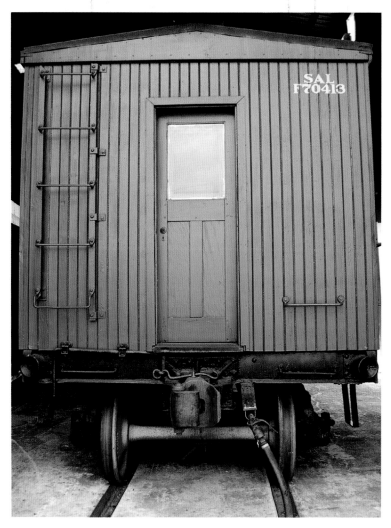

Kendrick Wayne Shackleford
Bunk
Duluth, Georgia

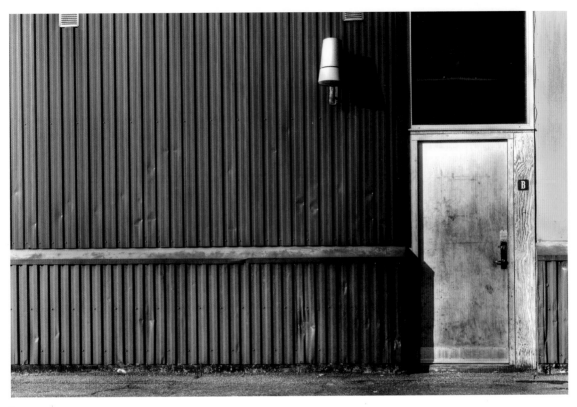

Jesper Dyhre Nielsen
Fynsgaarden
Esbjerg, Denmark

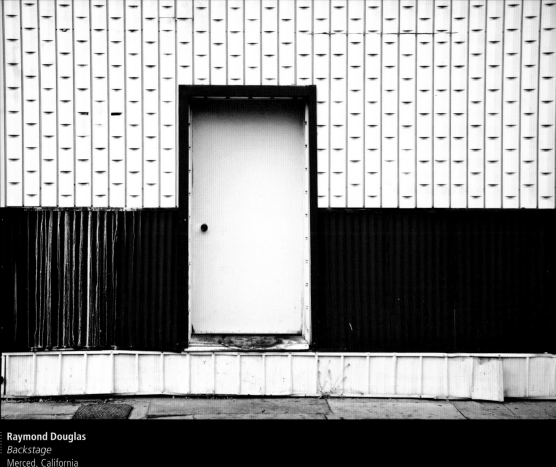

Raymond Douglas
Backstage
Merced, California

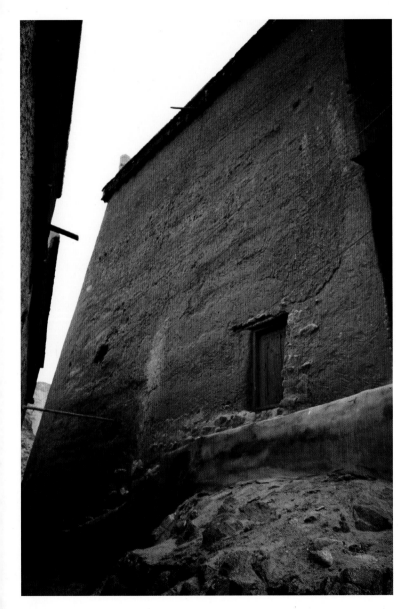

Pulkit Agrawal
The Red Building with the Red Door
Leh, India

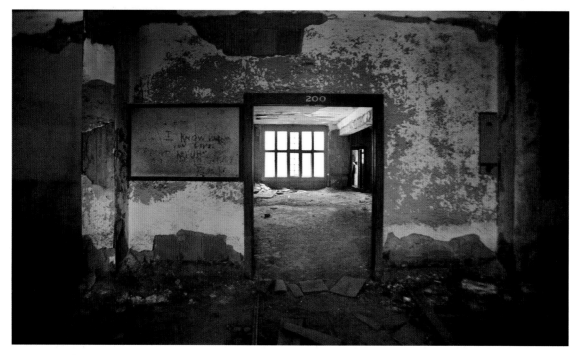

Vanessa Espinal
City Methodist Church
Gary, Indiana
The warm tone of this room and the number painted on the entrance-way drew me in. I looked through the doorway and immediately felt a sense of hope. The gold numbers took me back to the classrooms of my childhood and evoked feelings of nostalgia.

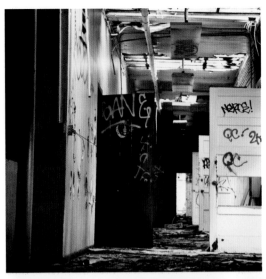

Tim Haley
Neros
Treasure Island, San Francisco, California

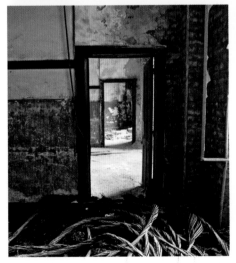

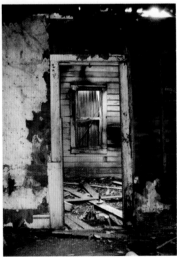

Justus Hayes
Upon Arrival
Cheratte, Belgium

Patrick Feller
Interior Door, Abandoned House, Aldine-Westfield Road
Spring, Texas

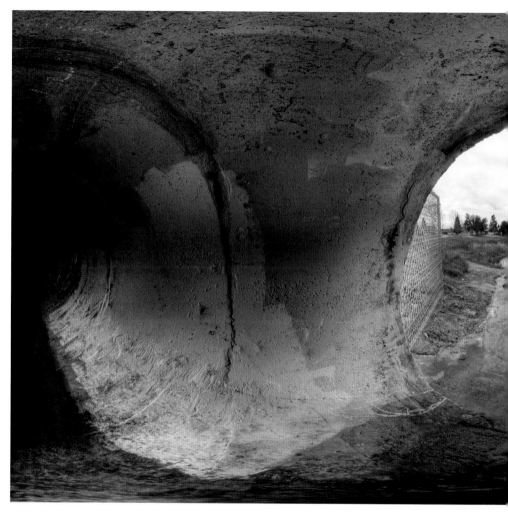

Josh Sommers
Looking In and Out
Petaluma, California
This photo was taken inside a drainage tunnel that runs beneath the Petaluma airport. As a child, I rode my bicycle through this tunnel, so—many years later—I was drawn back to the spot. I came equipped with my camera.

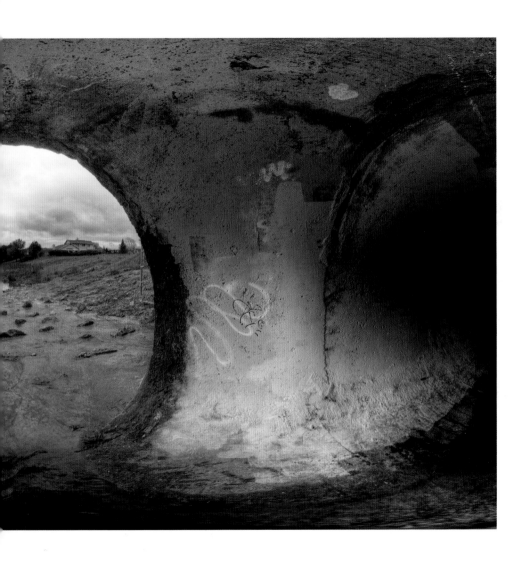

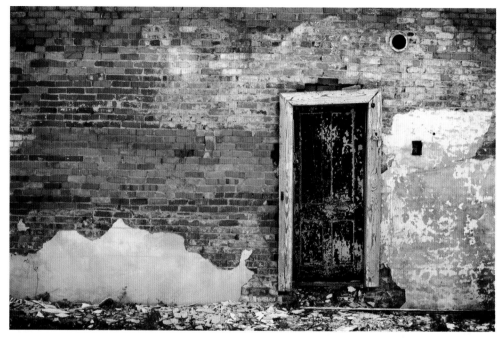

Tony Triolo
All That's Left
Belle Mina, Alabama

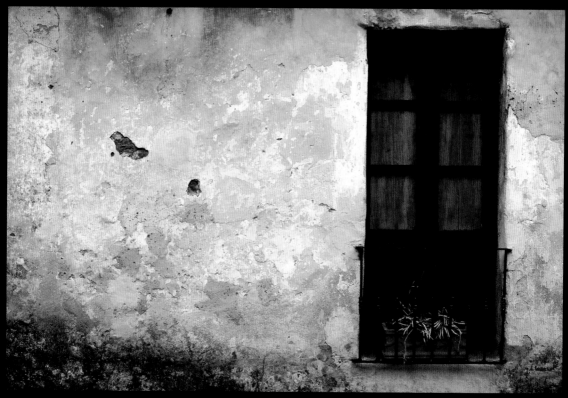

Maximiliano Heiderscheid
Untitled
Colonia del Sacramento, Uruguay

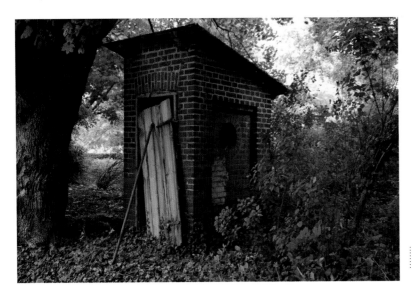

Bert Maathuis
Abandoned Toilet
Isle of Rugen, Germany

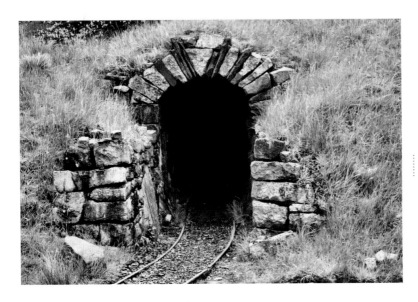

Martin Brewster
Mine Entrance
Threlkeld, Cumbria, England
This image shows a mine entrance
of the kind that would once
have been typical in this part of
England. Miners would clamber
down passages like this one, going
deep into the ground. The mines
are dark, wet, and full of hazards.

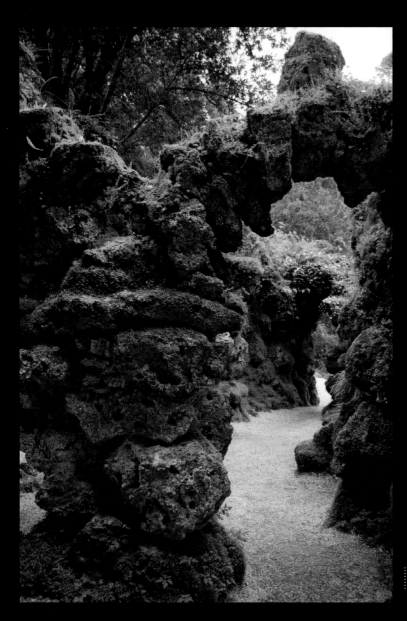

Stephanie Hatzakos
Moss
Dublin, Ireland

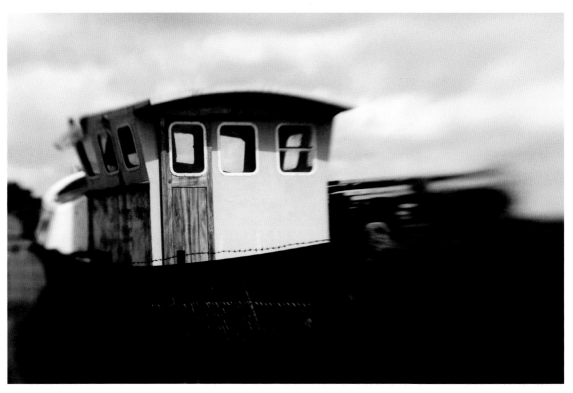

Simon Rooke
Lonely Vessel
Leigh-on-Sea, Essex, England

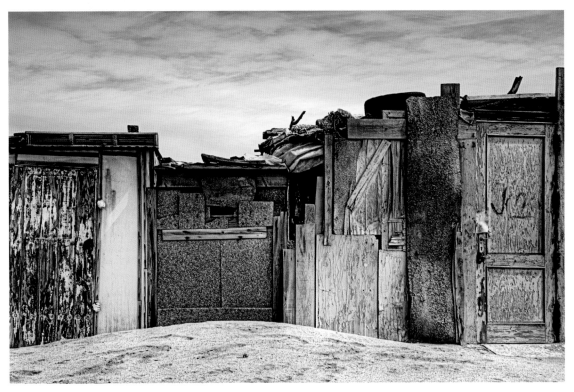

Sigrid Klop
Beach Houses
Almería, Spain

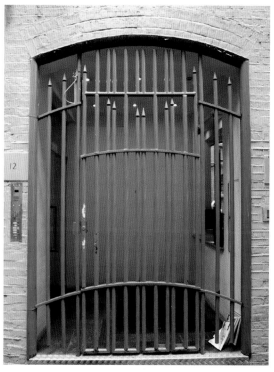

Mohanned Sid Ahmad
Neal's Yard
London, England

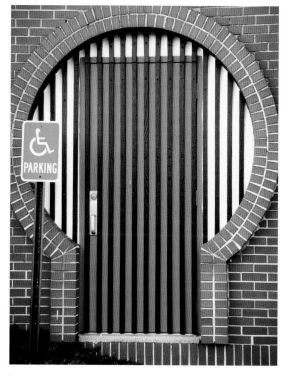

Cris Rea
Caged in Keyhold
Novi, Michigan

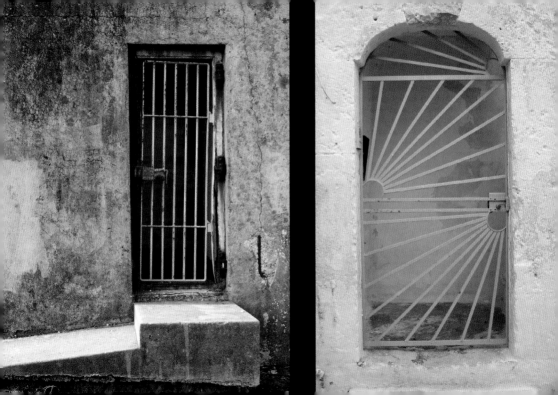

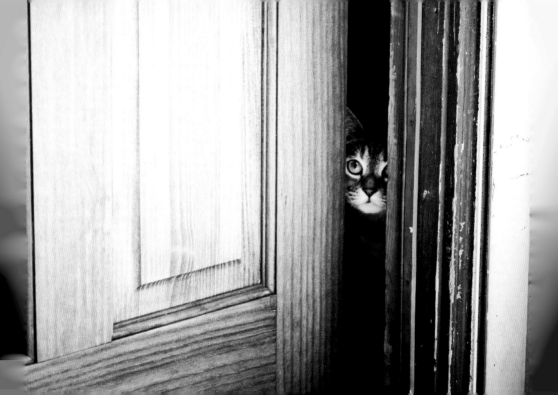

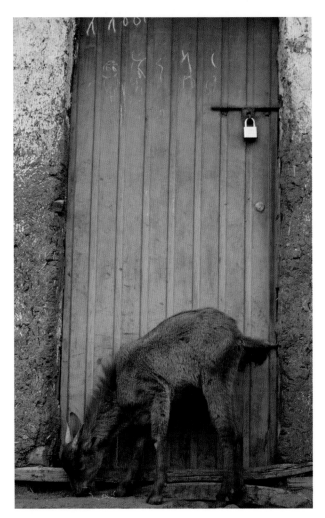

Emma Schwartz
Goat and Door
Debark, Ethiopia

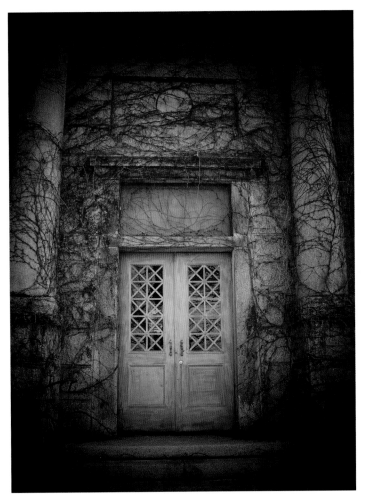

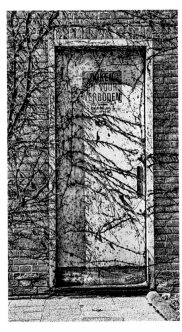

Sigrid Klop
No Smoking
Rotterdam, Netherlands

Mary Nyman
Mausoleum Doors, Glenwood Cemetery
Flint, Michigan

Patrick Feller
Nature Under Control
Houston, Texas

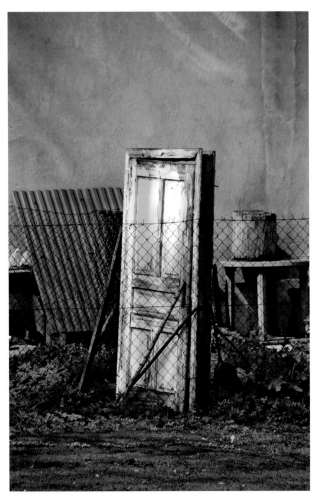

Ilja van de Pavert
Kraków
Kraków, Poland

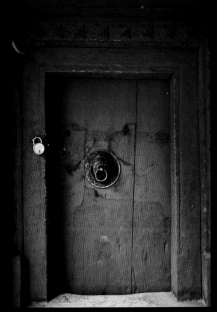

Pulkit Agrawal
The Small Red Door
Leh, India

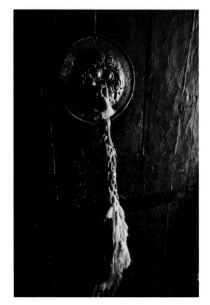

Pulkit Agrawal
Door Knob
Leh, India

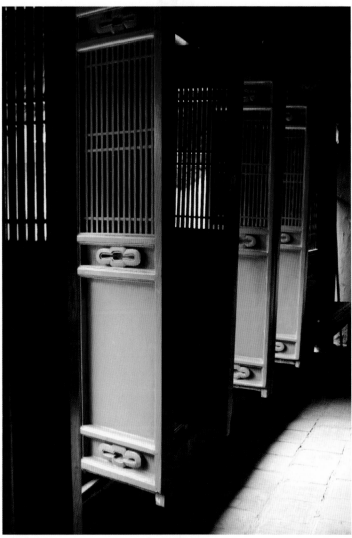

Chris Bryant
Louvered Doors
The Temple of Literature, Hanoi, Vietnam

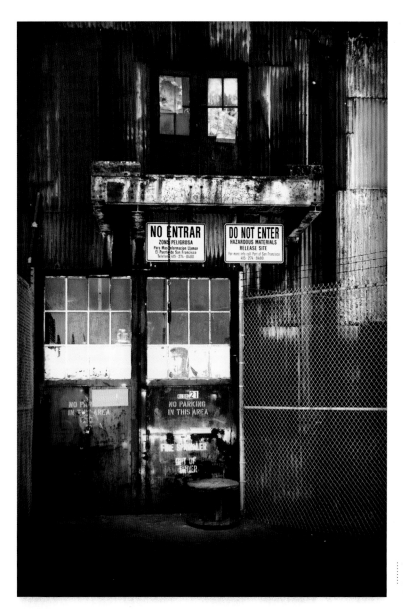

Tim Haley
Bldg 21
San Francisco, California

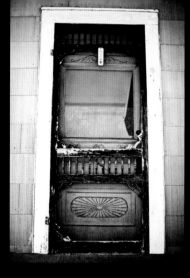

Adell Kinsman
Peeking Through the Past
Goshen, Alabama
Traces of the past still lurk inside this place. I can easily imagine two eyes peeking out at me from behind a shade, as I stand before the house and wonder about its history.

Simon Elgood
Old Lisbon
Lisbon, Portugal
The Alfama district is built on a steep hill in the medieval heart of Lisbon. This door is on one of the many stairways leading up to the Castle of Saint George, which dominates Lisbon's skyline.

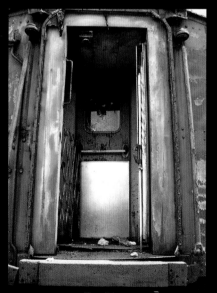

Kendrick Wayne Shackleford
Pullman Door
Duluth, Georgia

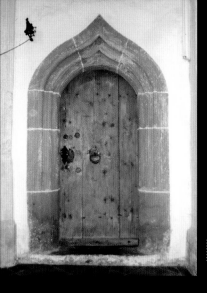

Heinz L. Kretzenbacher
Westerbuchberg
Westerbuchberg, Germany

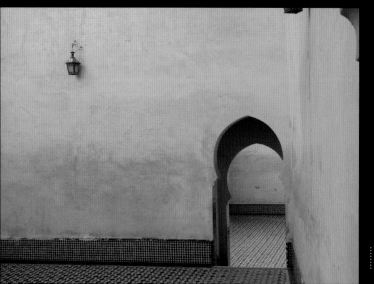

Cecilia Balint
Meknes
Meknes, Morocco

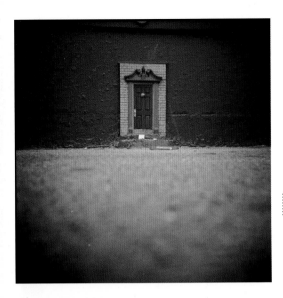

Pedro J. Martin Panadero
Fairy Door
Ann Arbor, Michigan
Fairy doors are small doors that appear on businesses around
Ann Arbor, attracting the attention of both kids and adults.
They feature incredible craftsmanship, color and detail. I saw
this one and had to take a photo of it.

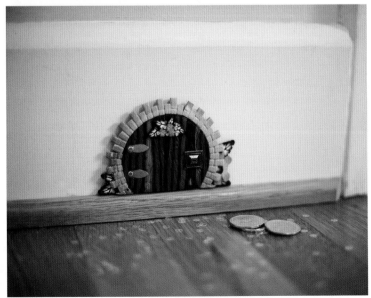

Angela Wright
The Tooth Fairy Has a Private Entrance
Richmond, Virginia
My daughter woke up the morning after
losing her first tooth to discover this fairy
door. It had magically been installed in her
bedroom during the night as she slept. The
tooth fairy left her a note explaining that
only good fairies can open the door. We were
honored that the tooth fairy felt she'd visit
often enough to need her own entrance.

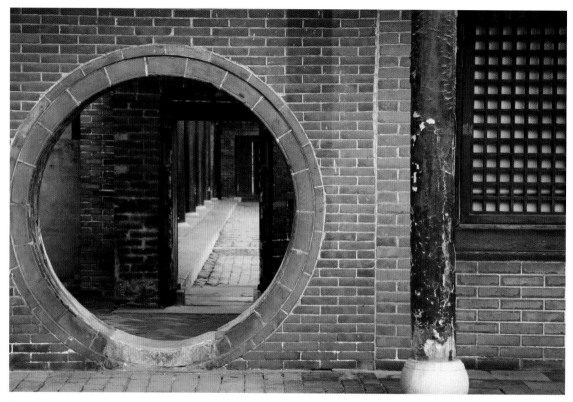

Gunter Hartnagel
Chinese-Style Gate in the Kong Family Mansion
Qufu, Shandong Province, China

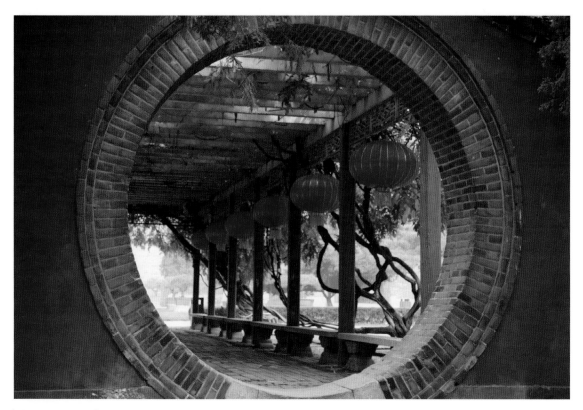

Gunter Hartnagel
Chinese-Style Gate in the Dai Miao Temple
Tai'an, Shandong Province, China

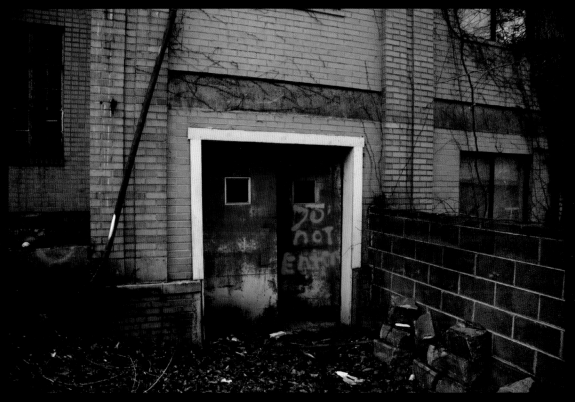

Lara Briann Miller.
Spray Paint Won't Stop Me
Williamson, West Virginia
My friends and I went into this abandoned hospital numerous
times, because—like most teenagers—we loved its haunted
quality. Not long after, we saw that a little message had been
left for us. That didn't stop us from visiting again, though.

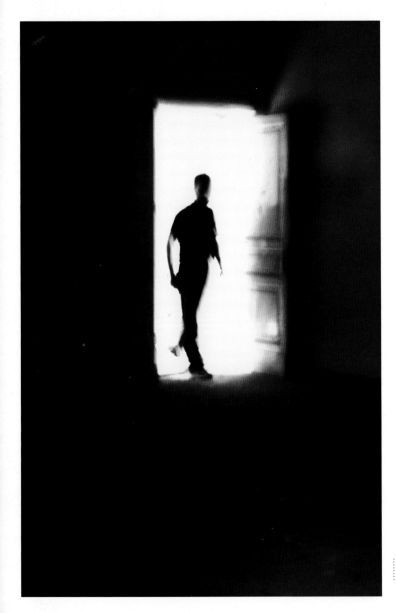

Cinzia Bazzanella
Coming In
Rovereto, Italy

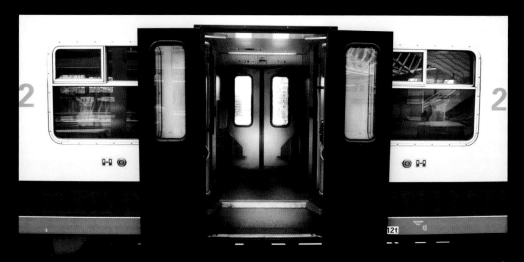

Frederic Giet
Bon Voyage
Liége, Belgium

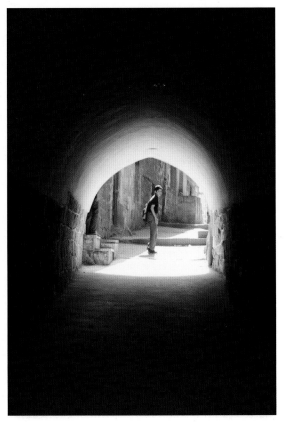

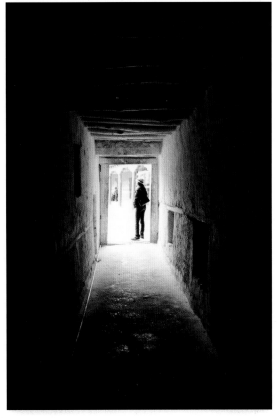

Gunter Hartnagel
Passage in the Old Quarter
Mardin, Turkey

Pulkit Agrawal
From Darkness Take Me to Light
Leh, India

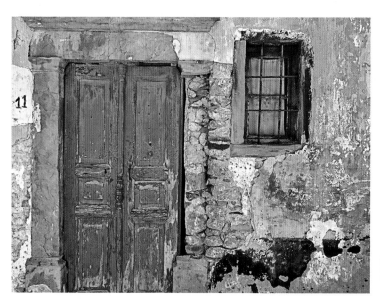

Flioukas Apostolis
Looking at the Past
Vessa Village, Chios Island, Greece

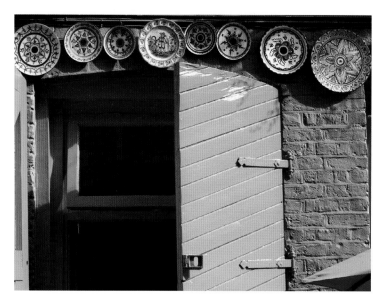

Mohanned Sid Ahmad
Neal's Yard 2
London, England

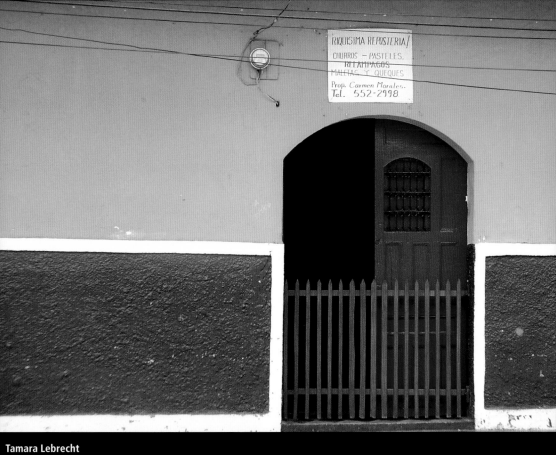

Tamara Lebrecht
Green Yellow Red Door
Granada, Nicaragua
In my opinion, this is the most appealing door on
La Calzada, Granada's main street.

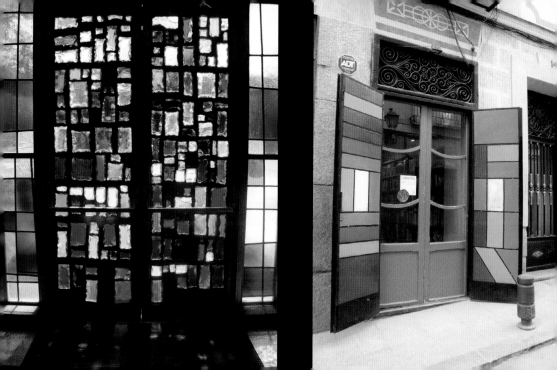

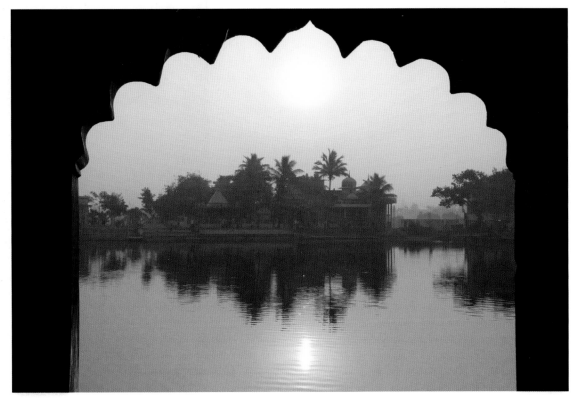

Debra Nickol/Warped Mind Photography
Green Door
Thurman, West Virginia

Geni M. Mermoud
Just Turn the Knob
Vaucresson, France
I'd driven past this door hundreds of times without ever seeing it. On a sunny day, I discovered it while walking. Its unexpected beauty startled me.

Cris Rea
Morning Light
Monterrey, Nuevo Leon, Mexico

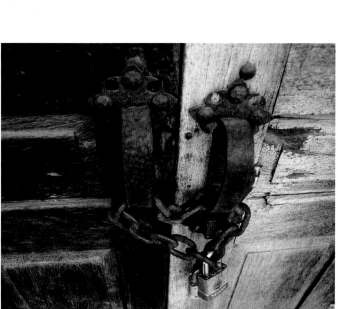

Luke J. Rosynek
Ebony and Ivory
Chicago, Illinois

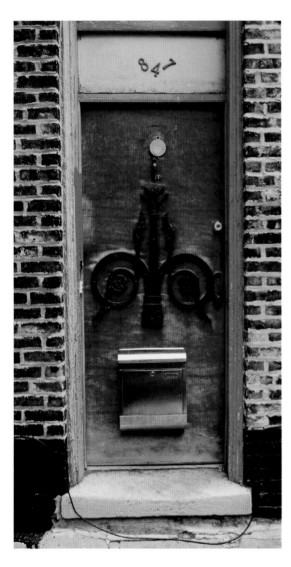

Abel Pau Garcia
The Newspaper in the Door
Tilburg, Holland
A door is a connection between two worlds—my own familiar one and an unknown one. A door is a thin film that's easily—and not so easily—penetrated, a boundary between two worlds that are possibly in conflict.

Luke J. Rosynek
847
Chicago, Illinois

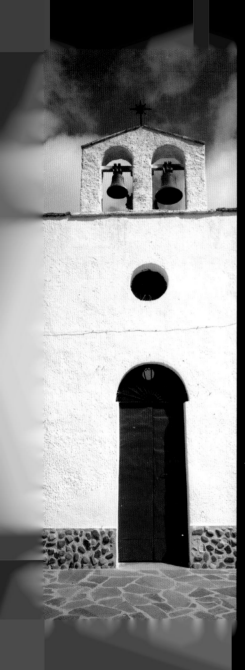

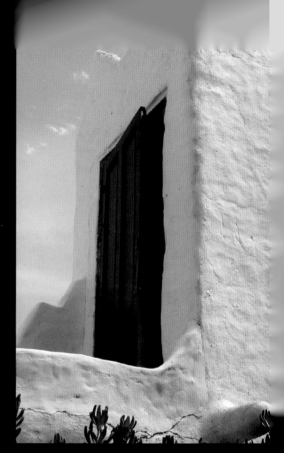

Judy Allen-Rodgers
Door Ajar
Casapueblo, Punta del Este, Uruguay
This is the mysterious door to the whimsical home and
museum of South America's beloved artist Carlos Páez
Vilaró. He built this "organic" fantasy house himself and
named it Casapueblo.

Manuel Cazzaniga
Villacidro Church
Villacidro, Sardinia, Italy

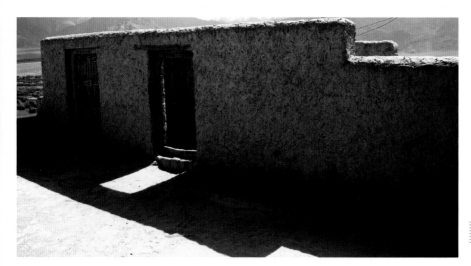

Pulkit Agrawal
Roof Door
Leh, India

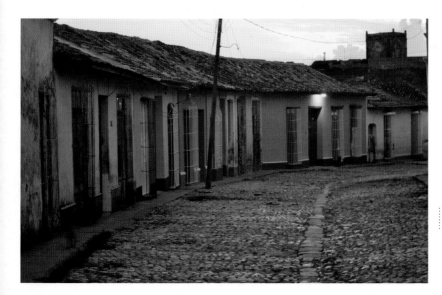

Stephanie Hatzakos
Colorful Cuba
Trinidad, Cuba
As a photographer and wandering
spirit, I view doors as symbols of
possibility and hope.

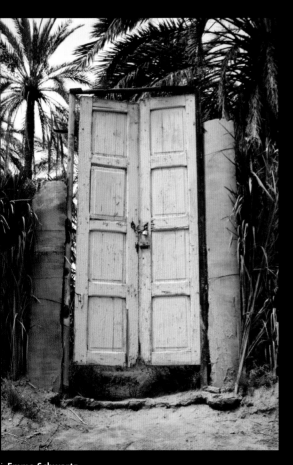

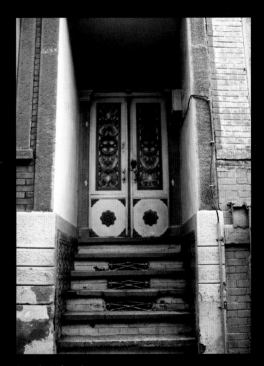

Leyla Ozluoglu
Blue Door
Izmir, Turkey

Emma Schwartz
Door in Palmerie
Nefta, Tunisia

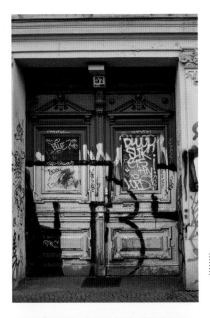

Liis Roden
Cultures Crossing
Kreuzberg, Berlin,
Germany

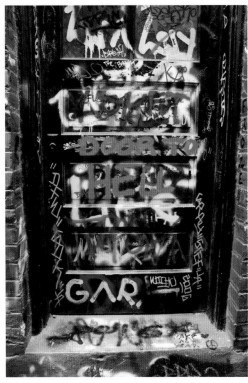

Cris Rea
Door to Hell
Ann Arbor, Michigan, United States
This image was shot in a place called Graffiti Alley. The
entire alley is a painter's canvas, and it changes on a
daily basis.

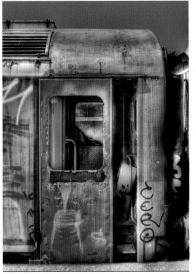

Dimitris Amvrazis
Half Open, Half Closed
Larissa, Greece

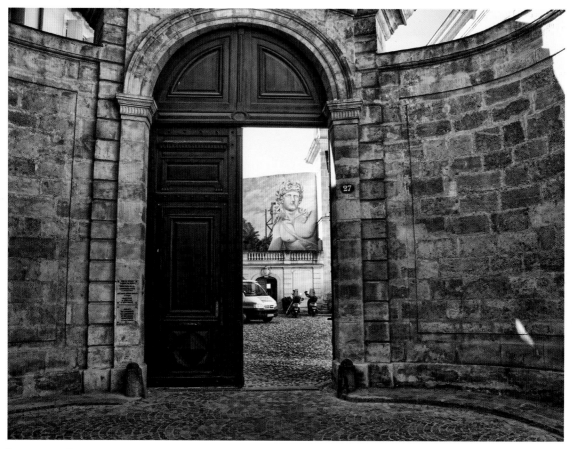

Bryan W. Bellars
Entrance to the Mayor's Office, Beziers
Beziers, Languedoc, France

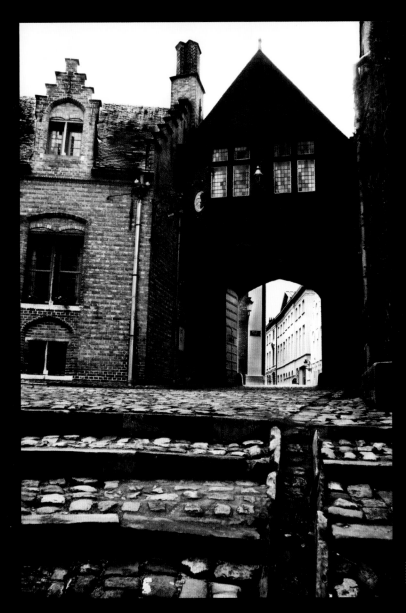

Frederic Giet
In Bruges
Bruges, Belgium

Nicole McConville
Study in Blue and Yellow
Prague, Czech Republic
There's something about the doors of Prague that immediately captures the eye of residents and visitors alike. After my trip there, I found myself seeking out doors of note during other travels around the world. Now I simply can't help but notice them.

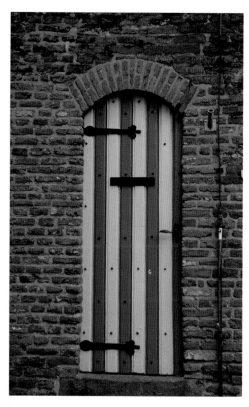

Ron M. Rademaker
Hattem Stadspoort
Hattem, Netherlands

Patrick Feller
Yellow Door, Jensen Drive
Houston, Texas

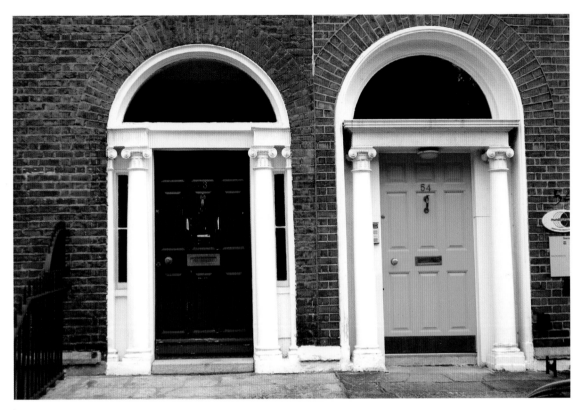

Heinz L. Kretzenbacher
Fitzwilliam Square
Dublin, Ireland

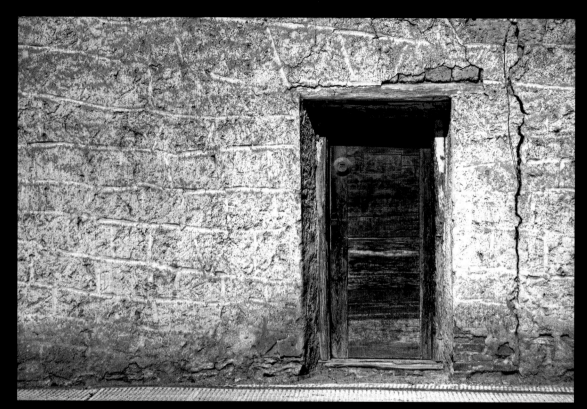

Sigrid Klop
Locked
Paracuellos de Jiloca, Spain

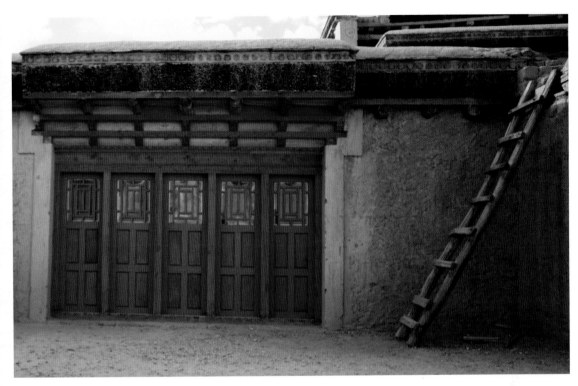

Pulkit Agrawal
Leh Palace
Leh, India

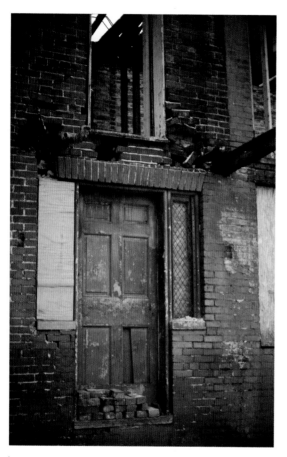

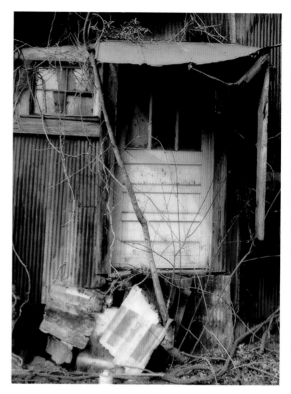

Kendrick Wayne Shackleford
No Entrance
Cartersville, Georgia

Vanessa Espinal
Baltimore Ruins
Baltimore, Maryland
This image symbolizes abandonment to me, since most of the
structure was destroyed, and the door is forced to stand alone
with no real purpose. The bricks stacked on the base of the
door give the scene an extra bit of mystery.

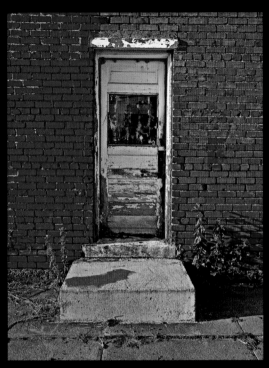

Wilson Hurst
Threshold
Windsor, Missouri

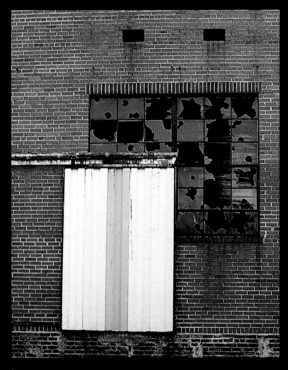

Kendrick Wayne Shackleford
Shattered Glass and a Door to Nowhere
Gainesville, Georgia

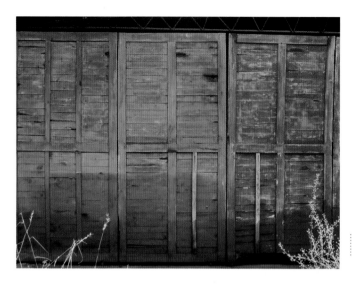

Kangan Arora
Green
Auroville, India

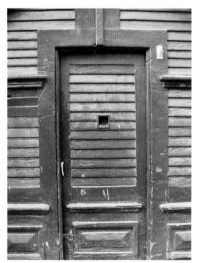

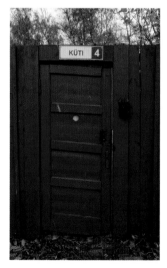

Cecilia Balint
Green
Szentendre, Hungary

Manuel Cazzaniga
Back Door
Tallinn, Estonia

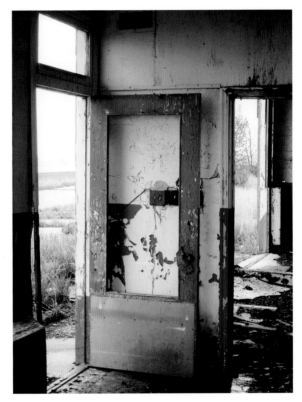

Darrin Hagen
Gas Station
Airdrie, Alberta, Canada

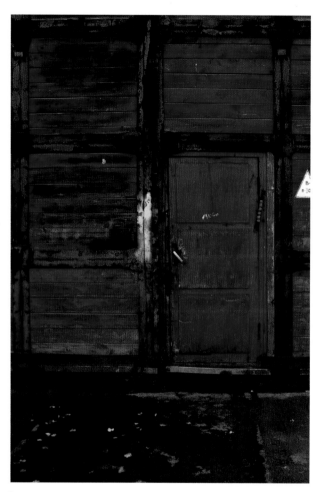

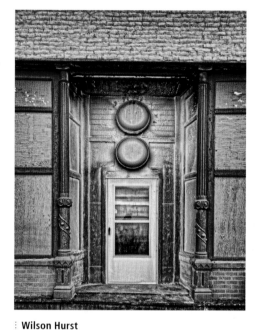

Wilson Hurst
Doorcorum
Missouri, California
Doors are boundaries, portals that may provide access
to alternate or expanded realms of perception. Until we
pass through a door, we never know what exists on the
other side.

Liis Roden
Red and Chained
Tallinn, Estonia

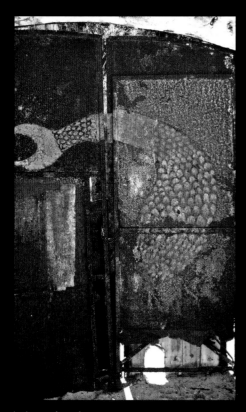

Simon Elgood
Fishy Door
Lisbon, Portugal
Visitors can take a ferry from Lisbon across the Tagus River to the largely deserted fishing port where this photo was taken. The port is full of warehouses in wonderful decay. I found this decorated door there, hanging on rusty hinges.

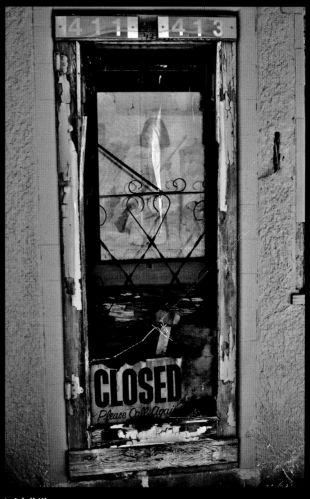

Adell Kinsman
Geronimo in the Door Window
Lordsburg, New Mexico

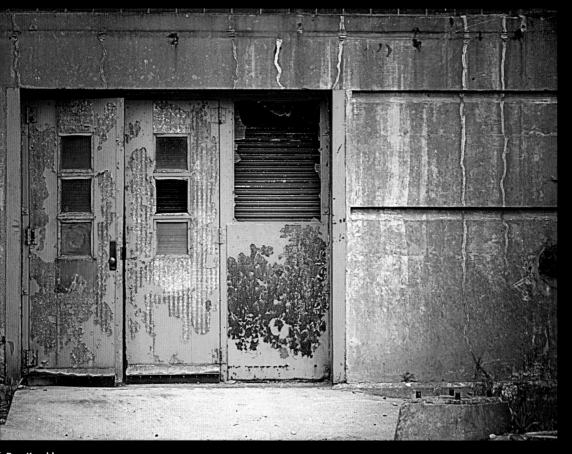

Dan Krecklow
No Longer Shiny and New . . .
Eau Claire, Wisconsin

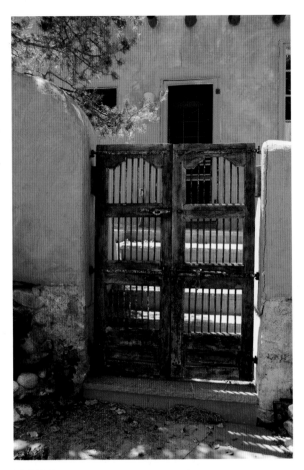

J.C. Fink
Canyon Road Turquoise Door
Santa Fe, New Mexico

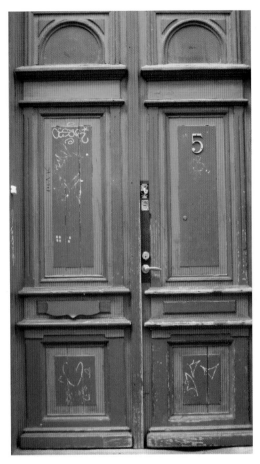

Julie Kerssen
Old Town Door 2
Tallinn, Estonia

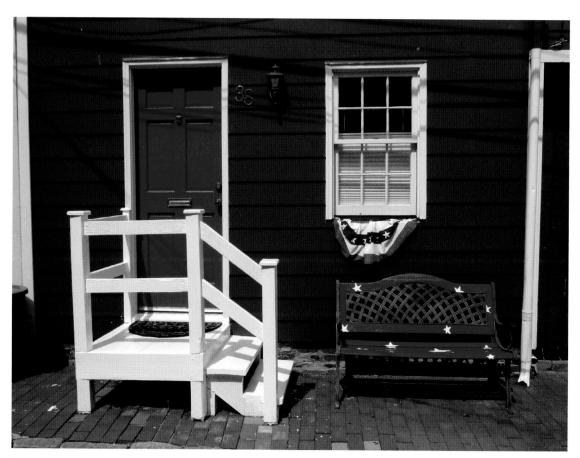

Manuel Cazzaniga
Entrance Door
Annapolis, Maryland

Wilson Hurst
Congruence
Boonville, Missouri

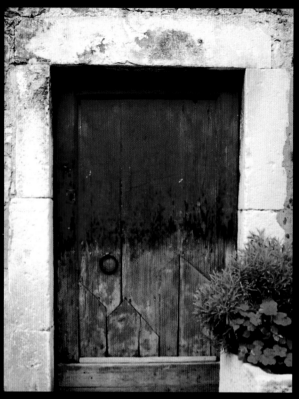

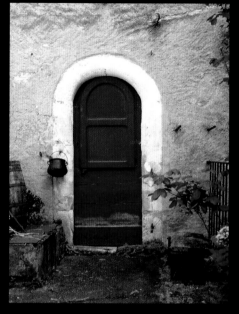

David Smith and Bonnie Smith
Doorway, Village Near Rocamadour
Dordogne Valley, France

David Smith and Bonnie Smith
Clever Door Repair
Trogir, Croatia

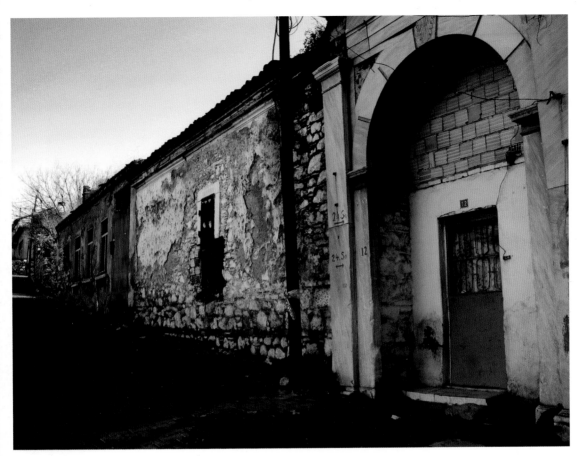

Leyla Ozluoglu
Ancient Door
Izmir, Turkey

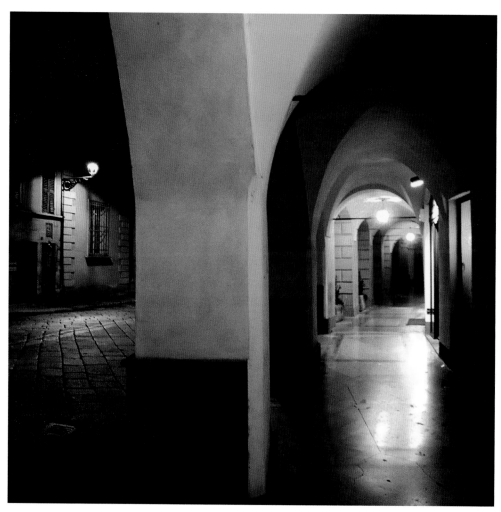

Rosetta Bonatti
Parma—Via Farini
Parma, Italy

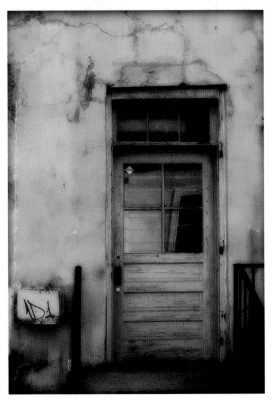

Kendrick Wayne Shackleford
Door at 1D1
Cartersville, Georgia

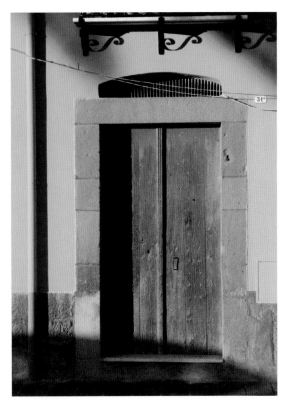

Manuel Cazzaniga
Entrance Door
Bosa, Sardinia, Italy

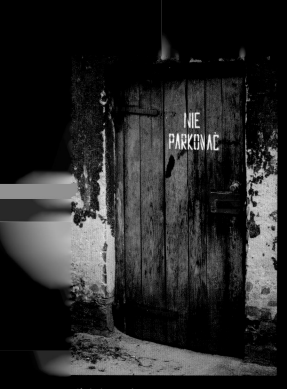

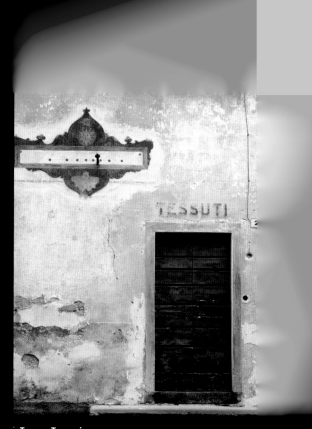

Christian Anderson
"No Parking" in Polish
Gdansk, Poland
I snapped this picture in Gdansk, Poland, while on a walk far from the center of the city.

Teresa Teruzzi
Transit Hora, Manet Opera
Pasturo, Italy
This door is in a small mountain town near the entrance to an old house. Beside the door is a wonderful Italian quote that reads, *"Il tempo fugge e più non fa ritorno, tu senza bene oprar non passar giorno."* ("Time passes by; it'll never come back. Never let one day pass without

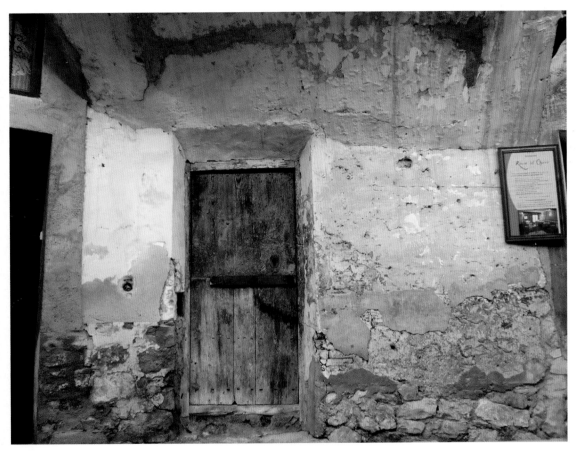

Marie-Aude Serra
Door
Aragon, Spain

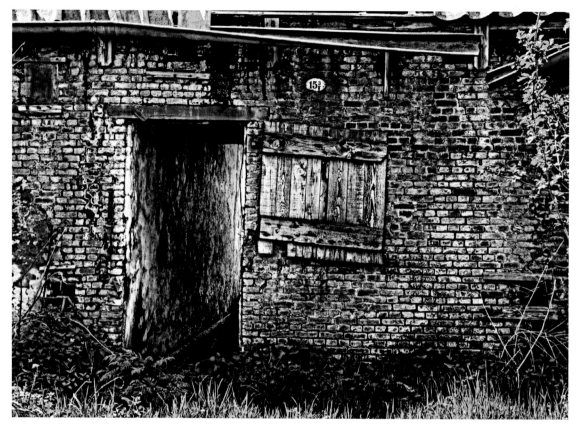

Sigrid Klop
Back to Nature
Schiedam, Netherlands

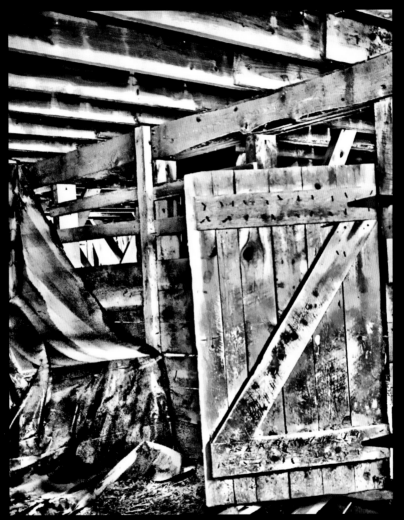

Debra Nickol/Warped Mind Photography
Barn Door
Mooresville, North Carolina

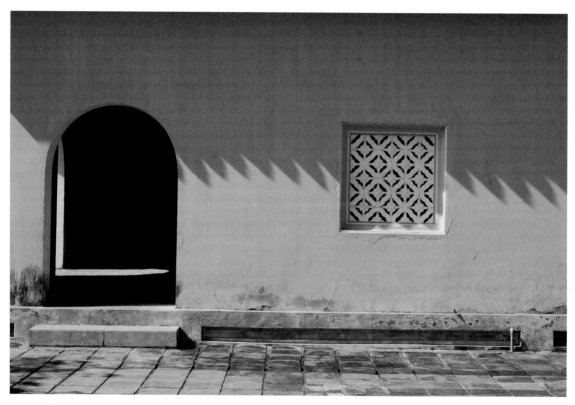

Stephanie Town
Midday Shadow
Forgotton Place, Hue, Vietnam

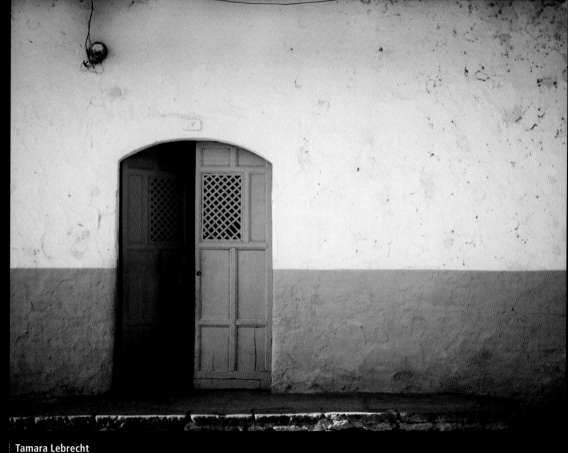

Tamara Lebrecht
Orange White Door
Granada, Nicaragua

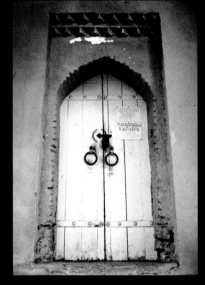

David Smith and Bonnie Smith
Gallery Entry Door, Museum
Alkhagori, Mtskheta-Mtianeti, Georgia

Robert J. Lowers
DSCF1821fin
French Quarter, New Orleans, Louisiana

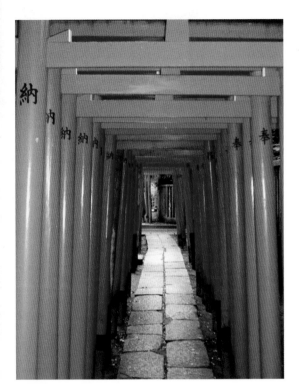

Federica Intorcia
Torii Gallery
Nezu Shrine, Tokyo, Japan

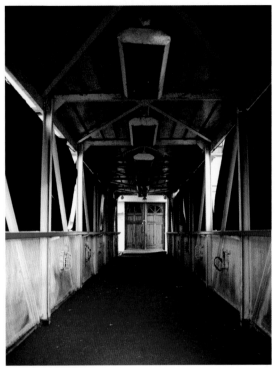

Vanessa Espinal
Binghamton Ferryboat
Edgewater, New Jersey
I saw this green pathway as I approached the Binghamton, an old ferryboat that's now a restaurant. The path lured me in. Before I walked up to the doors, I had to take this picture to show the perspective of the passageway and how inviting it was. Even though the doors are padlocked and the ferryboat is out of service, the doors still have an elegance to them. It's almost as if they're teasing you, keeping you from the mystery that's behind them, but giving you a small glimpse of what the ferry was like when it was functioning.

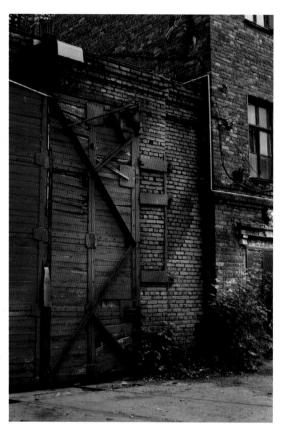

Liis Roden
Closed for Today
Tallinn, Estonia

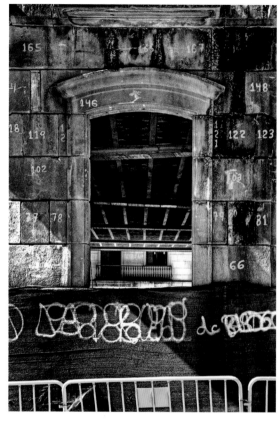

Sigrid Klop
Outnumbered
Vigo, Spain

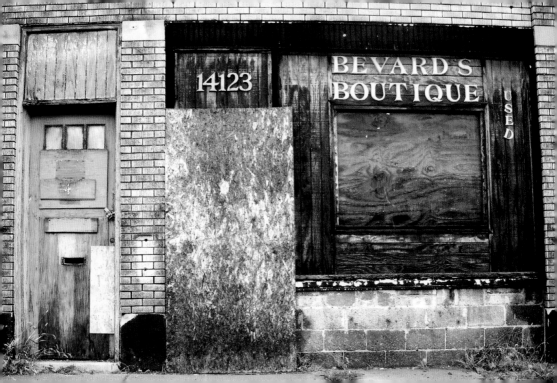

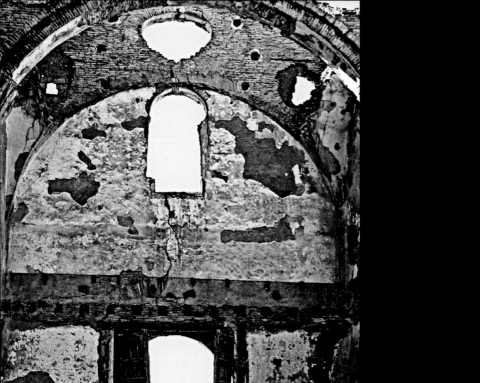

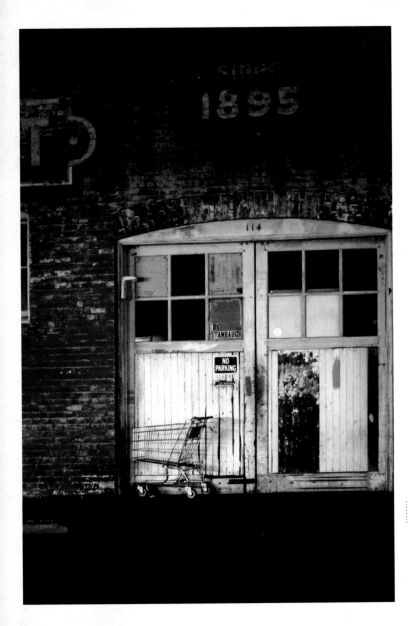

Tim Haley
Red Zone
Redwood City, California
Doors are both inviting and repelling.
They are silent sentries to both past and
present structures. As such, they offer
varying moods and suggest stories of
what may lie beyond them.

Emma Schwartz
Turquoise Door
Matmata, Tunisia

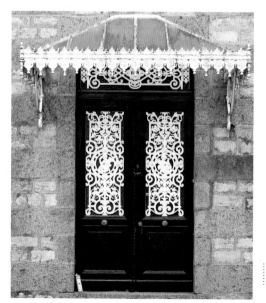

Cecilia Balint
Vintage Beauty
Samos, Greece

Atie van Ruller
Middle-Class Style
Couterne, France

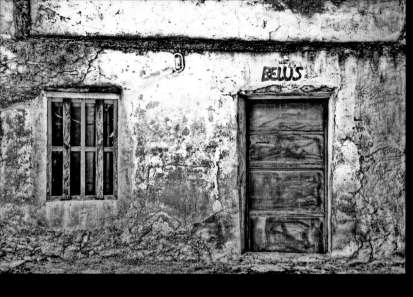

Sigrid Klop
Villa Belus
Paracuellos, Spain

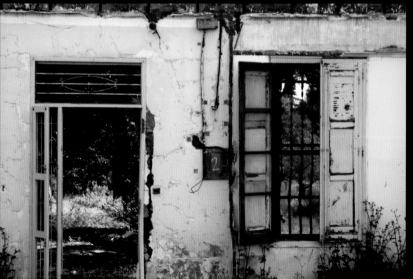

Fabián Flores Gómez
Broken House
Barcelona, Spain

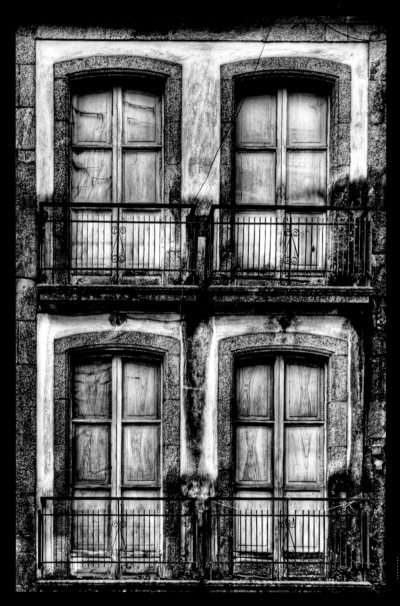

Sigrid Klop
High Passages 1
Santiago de Compostela, Spain

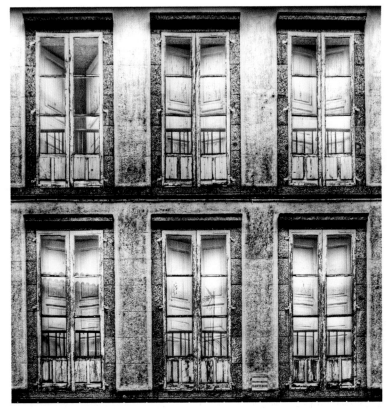

Sigrid Klop
Parochialism—The Doors
Santiago de Compostela, Spain

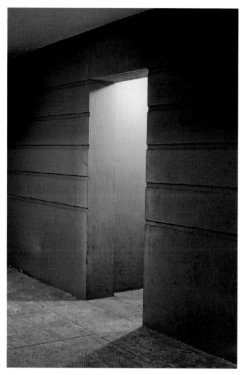

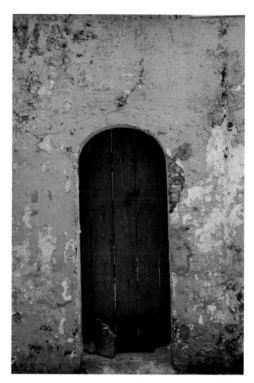

Byron Barrett
Green Door
Vancouver, British Columbia, Canada
The escaping light in this image attracts one's
eye. What's behind the door? Who's about to
emerge? The viewer can only imagine.

Chua Wei Luck
Back Door
Singapore

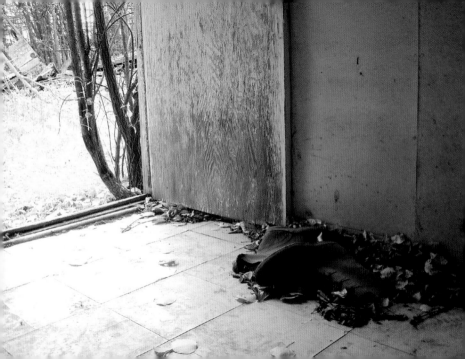

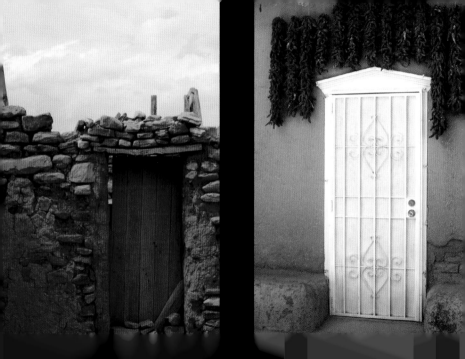

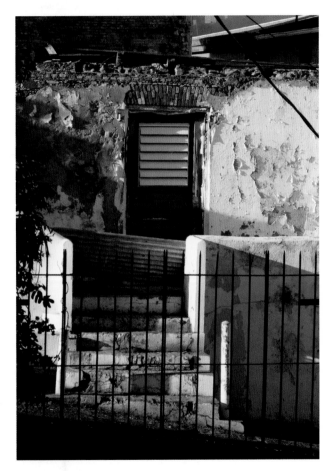

Jeanne M. Julian
Prindcesse Gade
Charlotte Amalie, St. Thomas, U.S. Virgin Islands

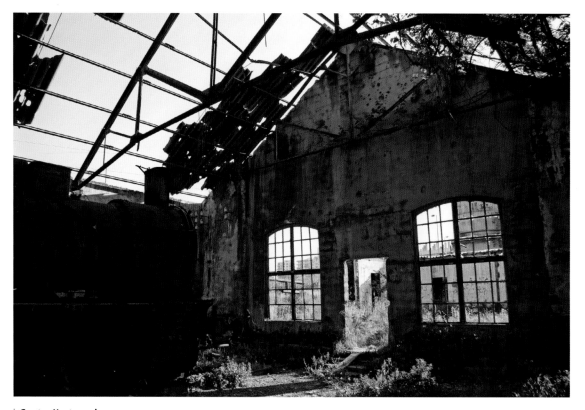

Gunter Hartnagel
Former Repair Hall of the Lebanese Railway
Tripoli, Lebanon

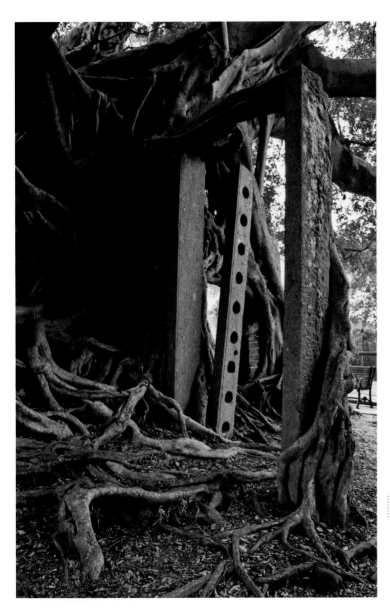

Ali Tse Chung Kwan
The Abandoned Door
Kam Tin, Hong Kong, China
This door is part of a collapsed brick house
that has been joined with a huge banyan
tree for years. When I passed through the
door, I couldn't tell whether I went through
an entryway or a tree.

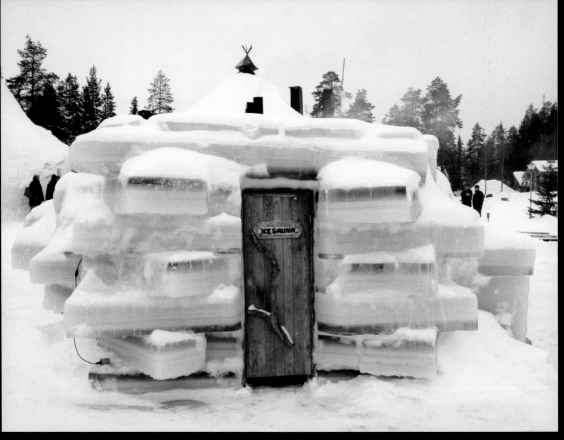

Manuel Cazzaniga
Ice Sauna in Lapland
Rukatunturi, Lapland, Finland
This is the door to a sauna built entirely from ice on a frozen lake
in Finnish Lapland. Inside, the temperature was 50°C!

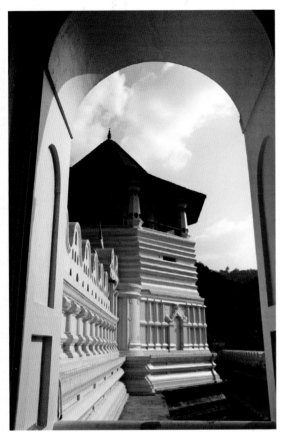

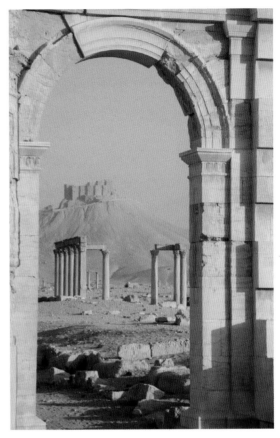

Gunter Hartnagel
Gate at the Sri Dalada Maligawa Temple
(Temple of the Tooth)
Kandy, Sri Lanka

Gunter Hartnagel
Roman Gate in Palmyra with View to
Qala'at Ibn Maan, an Arab Citadel
Palmyra, Syria

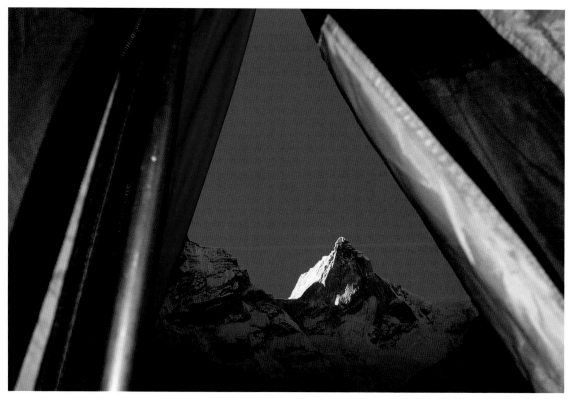

Lopamudra Barman
Unzipped Morning!!
Garhwal Himalayas, near Gangotri Town, Uttaranchal, India

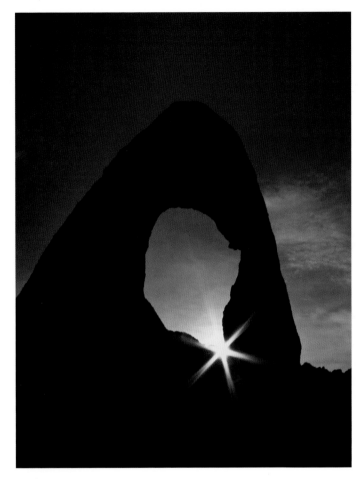

Rich Greene
Sun Through Whitney Portal Arch
Lone Pine, California
Many photographs taken in this area show the Eastern Sierra Mountains in the
distance. With this picture, however, I was trying for something different. I set
up to take my shot on the western side of the arch, hoping to catch the rising
sun as it cleared the hills to the east.

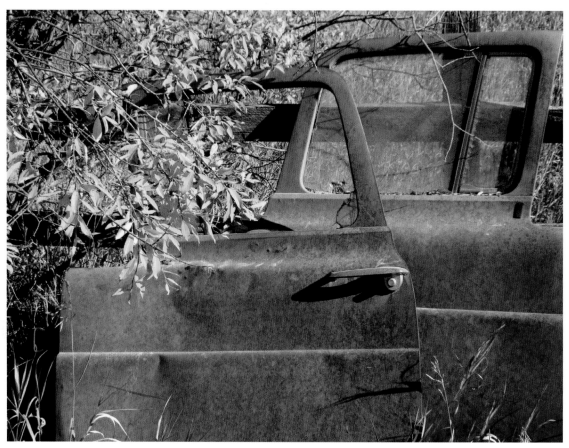

Darrin Hagen
The Doors
A few miles north of Valhalla Centre, Alberta, Canada

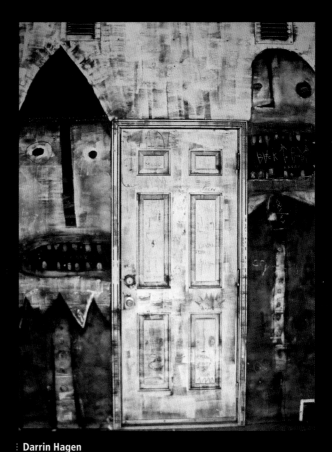

Darrin Hagen
Right This Way
Halifax, Nova Scotia, Canada
I wander the streets looking for moments that will make good photos. It could be something as simple as the way the light hits a wall or a strange confluence of lines. Once in a while, however, I stumble upon an image worthy of any gallery. This picture was taken in downtown Halifax. I have no idea what's on the other side of the door, because there was no sign—just these two characters, making sure I stayed on my side of the door.

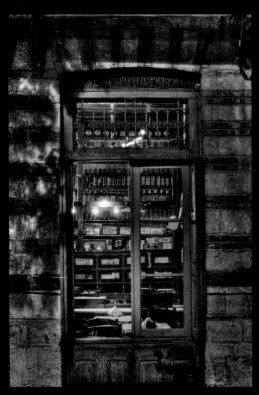

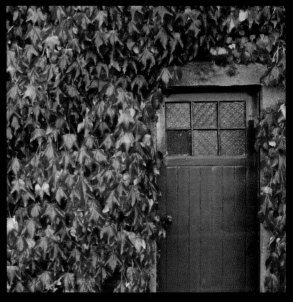

William T. A. Muir
Blue Door to Autumn World
Tweed River, Roxburgh, Scotland
Taken on the banks of the famous salmon fishing river, the Tweed. Beside a partial dam of the river are what looks like an old mill and some cottages. One of the cottages was covered in ivy turning to autumn red. The blue door just seemed to pull out all the colors.

Dimitris Amvrazis
Inside Nikodimos'
Larissa, Greece

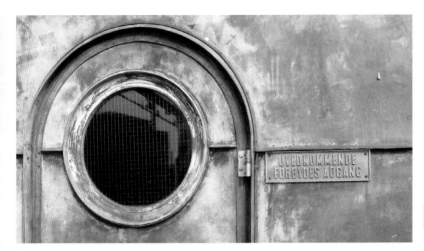

Amy Sansom
Forbidden Entrance
Copenhagen, Denmark

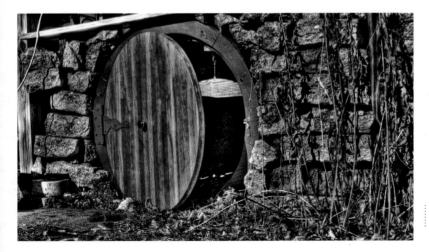

Benu Peters
Round Door
Sioux Falls, South Dakota

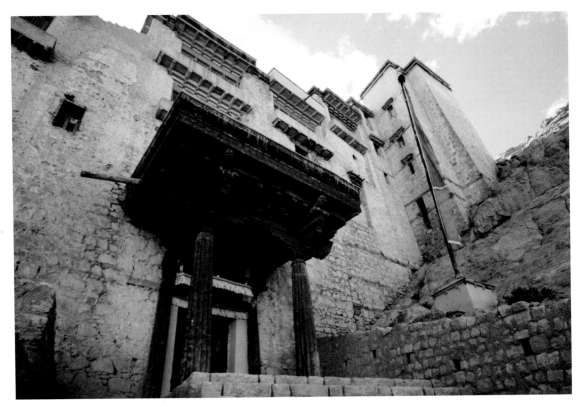

Pulkit Agrawal
Leh Palace Entrance
Leh, India

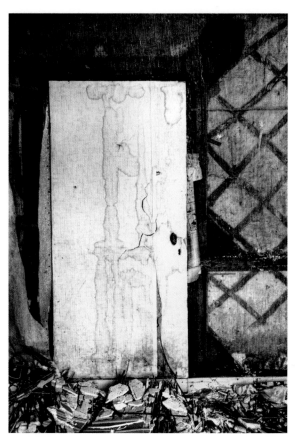

Sigrid Klop
Useless
Schiedam, Netherlands

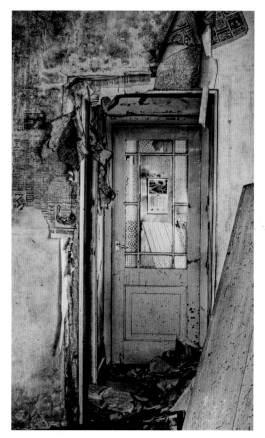

Sigrid Klop
1993
Schiedam, Netherlands

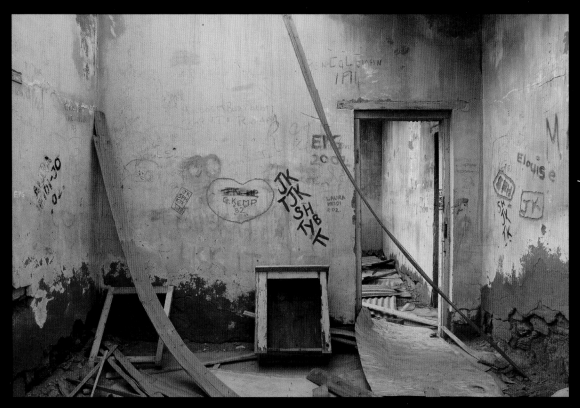

Stephanie Town
Empty Cabinet
Marree, Australia

Index of Contributing Artists

Also avaiable in the F\bigcircCUS series:

ISBN: 978-1-60059-563-9

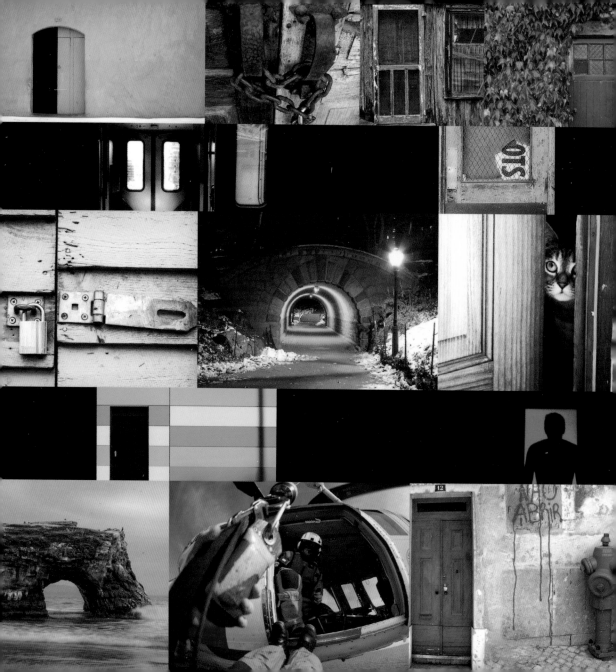